IMAGES
of America

VAN LEAR

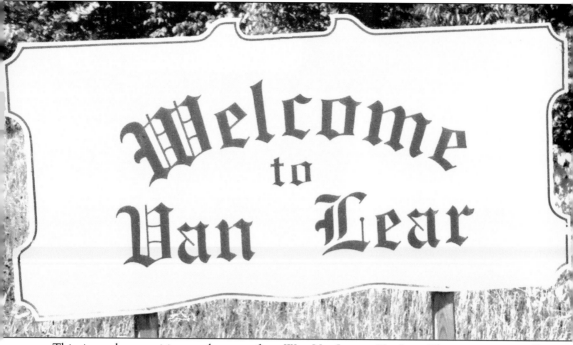

This sign welcomes visitors as they cross from West Van Lear to Van Lear. The sign was originally installed by the City of Van Lear when the city was incorporated. It was installed at its present location by volunteers of the Van Lear Historical Society. (Photograph by Danny K. Blevins.)

ON THE COVER: This picture was taken by a photographer employed by the Consolidation Coal Company. Shown is a group of miners who worked loading coal in Mine Number 154. (Courtesy of the Van Lear Historical Society [VLHS].)

IMAGES
of America

VAN LEAR

Danny K. Blevins

ARCADIA
PUBLISHING

Published by Arcadia Publishing
Charleston, South Carolina

Printed in the United States of America

Library of Congress Catalog Card Number: 2007928481

For all general information contact Arcadia Publishing at:
Telephone 843-853-2070
Fax 843-853-0044
E-mail sales@arcadiapublishing.com
For customer service and orders:
Toll-Free 1-888-313-2665

Visit us on the Internet at www.arcadiapublishing.com

To my dad, Danny E. Blevins, my aunt Patsy J. Webb, and Hubert Butcher: you are all deeply loved and sadly missed.

CONTENTS

ACKNOWLEDGMENTS

I would like to extend my greatest appreciation to the Van Lear Historical Society for the unrestricted use of its photographic archives and printed materials. Also, my thanks go out to the staff of the Johnson County Public Library for all their assistance in the use of their extensive reference and microfilm collections.

I also wish to thank the many individuals who have helped in some respect to the production of this project: Adam Lyons for his help in correcting my rough drafts; Clarice Kelly of the Lawrence County, Kentucky, Public Library for research; James and Ann Tramel for loans of material; Eric Thomas, Jennifer Newman, and Kathryn Zylland of the East Kentucky Science Center for assistance in processing photographic images; Hattie Books, Russell Rice, Tasha Williams, Roger Williams, Frankie Austin Cantrell, Russell "Bill" Rucker, John and Shelia Bowling Sparks, Howard Sparks, Louise Kretzer, Sharon Ward Fannin, the Marion Ward family, Debra Arrowood Spence, Terry Quillen, Herman Bolin, James "Tedo" Vaughan, and Tina Webb for their contributions of photographs and information; and Kendra Allen and Lauren Bobier of Arcadia Publishing for their guidance and advice. Lastly, I wish to express my love and gratitude to my wife, Trudy, and our children, Tracy, Trevor, and Morgan, for supporting this project.

INTRODUCTION

In a quick glance, the history of Van Lear, Kentucky, probably mirrors the histories of countless other towns that were constructed by large industrial corporations. The differences in these histories lie below the surface and are intimately tied up in the stories of the people, organizations, and structures that mesh together, creating unique communities.

Van Lear is located in the Eastern Kentucky Coalfield in southeastern Johnson County. The county was named for Col. Richard Mentor Johnson, a Kentuckian who became vice president of the United States. Most of Van Lear proper lies along the narrow valley drained by Miller's Creek, a tributary of the Levisa Fork of the Big Sandy River. Like most of Eastern Kentucky, Johnson County is covered by the foothills of the Appalachian Mountains. Often these hills are incorrectly called mountains, but there are no true mountains to be found in Johnson County. In fact the highest point in the county, Stuffley Knob with an elevation of 1,508 feet, falls short of what most would consider a bona fide mountain.

Before its development, the valley that was to become Van Lear was called Miller's Creek. Only a few farm families populated the area. It is unknown how the area came to be called Miller's Creek. According to noted historian Edward R. Hazelett, the name may have originally been Millard's Creek in honor of a resident bearing that surname, but later was corrupted to Miller's Creek. The stream may have gained the name Miller's Creek after William Conley, a millwright who drowned while helping to build a mill near present-day Prestonsburg. The Conleys were living on a large farm near the mouth of Miller's Creek at the time, and it was there that William was laid to rest. Perhaps after Conley's tragic episode, the captains of the riverboats that traversed the Levisa Fork noted the location as the Miller's Creek. Whatever the case, we will probably never know for sure.

In the late 19th century, Johnson County contained many, often one-roomed schools. Miller's Creek had an upper school and a lower school; the upper school was in what is today Butcher Hollow, and a lower school near the mouth of Sorghum Hollow. It was in the Lower Miller's Creek School that a young, ambitious schoolmaster by the name of John Caldwell Calhoun Mayo was to ply his craft.

One of the subjects the young Mayo had studied at college was geology. He began to think about the untapped seams of coal that lay undisturbed throughout Eastern Kentucky and Southwestern Virginia. John Mayo dreamed of what could be, if only the railroad were extended southward to provide a convenient outlet for this vast resource. In 1881, the Chatteroy Railroad was constructed from Ashland, Kentucky, running southward to the mining town of Peach Orchard in Lawrence County. The line was not extended to Whitehouse in Johnson County until the year 1887 and not to the county seat of Paintsville until 1904.

In 1886, John C. C. Mayo began to dabble in real estate, forming a company along with local businessmen Dr. I. R. Turner and F. M. Stafford. Two years later, Mayo was involved in another real estate company whose stated purpose was to acquire land and mineral rights. Mayo furthered his holdings of land and mineral rights when he formed the Paintsville Coal and Mining Company

in 1889. The following year he owned or held leases or options to lease or buy approximately 30,000 acres of coal-bearing lands in Eastern Kentucky. In 1891, Mayo acquired most of the Elkhorn Creek coal seam.

John Mayo attended the Chicago World's Fair in 1893. There he displayed coal from Kentucky and attracted the attention of a very wealthy businessman, P. L. Kimberly. Kimberly bought into some of Mayo's holdings and gave him a check for $10,000. Not only did Mayo gain this much-needed sum of money, but he also retained a quarter interest in the land, and Kimberly authorized him to be able to draw more funds as the property was further developed.

Mayo's first substantial deal came when he persuaded five brothers by the name of Merritt who were into the iron industry to invest in some of his coal holdings. Mayo explained to the Merritts the advantages of locating facilities for the production of steel in the Ashland, Kentucky, and Ironton, Ohio, area. Mayo sold them 29,000 acres of property in exchange for $60,000 cash and a note for an additional $100,000. What John Mayo did not know at the time of this deal was that J. D. Rockefeller held a $500,000 mortgage on the Merritt's investment. This fact came to light when Rockefeller foreclosed during the panic of 1893.

Mayo continued through the years establishing companies and making deals. In 1901, Northern Coal and Coke Company was incorporated in West Virginia. He transferred major holdings in the Kentucky counties of Floyd, Johnson, and Lawrence to this company. In exchange for these vast tracts, Mayo received a quarter of a million dollars and 25 percent of the company's common stock.

In 1906, Mayo opened a mine west of Wolfpen Branch in Miller's Creek. Trying to promote coal to eastern industrial magnates, Mayo had some of the Miller's Creek block coal taken to the Jamestown Exposition. Once at the exposition, the coal was fashioned into a coal house and became a very popular exhibit.

In 1909, Northern Coal and Coke came into possession of an excess of 130,000 acres of coal lands in the Elkhorn field. Shortly thereafter, Northern Coal and Coke sold its Miller's Creek properties to the Consolidation Coal Company (Consol). Consol paid $4.5 million for coal properties in excess of 100,000 acres and mineral rights in the Elkhorn field. Mayo was well on his way to becoming Kentucky's wealthiest citizen, and the valley of Miller's Creek was about to undergo a transformation into a major coal-producing city.

The city to be constructed at Miller's Creek would be called Van Lear in honor of Van Lear Black. Black was a very successful businessman from Maryland who was a member of Consol's board of directors. It was a common practice for company towns to be named for influential industrialists who served as directors on corporate boards. In 1909, the first U.S. post office was established and named Van Lear. The first postmaster for this facility was Frederick H. King.

The Miller's Creek Railroad (MCRR), a short-line railroad, was built with the backing of Van Lear Black's Fidelity and Deposit Company. This railroad ran from the Levisa Fork at the west end of Van Lear to near the mouth of the present Butcher Hollow in the east. In 1910, a bridge was constructed across the river, allowing coal to be hauled to a junction with the main-line track that had been greatly extended southward. The loaded coal cars were transferred to trains going to the large commercial outlets, and empty cars were then pulled into Van Lear by the MCRR, starting the process all over again.

Van Lear became an officially recognized city on June 15, 1912, when articles of incorporation were filed with the Johnson County Circuit Court. The new city's first officials were appointed, and the city began to function not only as a unit of a company but also as a civic entity.

Van Lear became the most populated community in Johnson County with over 4,000 citizens, while the county seat of Paintsville had a population of about a quarter of this size. Van Lear's population was a cosmopolitan mix that included people with very diverse backgrounds. Employment opportunities were extended not just to the native Eastern Kentuckian population but to all qualified workers. Many immigrants from Europe and many African Americans from the Deep South came to work in Van Lear. This was in stark contrast to some mining communities that rejected anyone perceived as being an outsider.

Living conditions in Van Lear far exceeded those found in the smaller coal camps. The miners and their families lived in comfortable homes with electricity and city water via lawn hydrants. Educational, recreational, civic, and religious opportunities abounded. Van Lear's citizens were encouraged to be well-rounded and productive citizens.

The community functioned well into the 1940s, when Consol divested itself of the non-mining aspects of the town and shortly thereafter ceased mining operations. Others mined in Van Lear, but never on the scale of Consol. Jobs were lost and the population waned. Workers moved their families to areas with greater employment opportunities. The industrial Midwest would attract the majority of these working class families.

The reduced population saw a decline in business opportunities, and the city's government was declared inactive by the circuit court in 1963, at the request of some of its citizens. The Van Lear public schools also suffered from the diminished tax base and were consolidated into the Johnson County School System in the 1960s. The last class to graduate from Van Lear High School was the class of 1968. The following school year marked the opening of Johnson Central High School in Paintsville. Van Lear continued to have a grade school until the opening of Porter Elementary at Hager Hill in 1973.

During the 1970s and 1980s, much of the coal lying in the upper strata was strip-mined using a form of the open-pit method. Much of this coal was trucked to a tipple owned by one-time Johnson County judge James C. Witten. At this time, only a short section of the railroad spur running into Van Lear remained. As the strip-mining ceased, the tipple fell into disrepair, and the remaining tracks and the railroad bridge were removed. This was the last tipple operated within Van Lear proper.

Today a small mining operation is in production very near the former location of Consolidation Coal Company's Mine No. 155. It is hard to say what the future of coal mining might have in store for Van Lear, especially in light of the constant turmoil in the oil-producing regions of the Middle East. Some speculate that Eastern Kentucky could become a major center for coal-based alternative fuels.

An attempt was made in the 1990s to revive the city, and Van Lear was reincorporated for a few years. Progress in the community was being made, as the city saw the revival of a police department, and a laborer was hired to keep the community clean. Unfortunately, various factions of the population split the community on the issue and the city government was controversially removed. Without an officially recognized leadership in the community, development has become somewhat stagnant. Most of the positive actions taking place these days are due to the projects of the Van Lear Historical Society and the Van Lear Volunteer Fire Department.

The Van Lear Historical Society is a nonprofit organization dedicated to the preservation of the history and heritage of the community of Van Lear. The society operates the Coal Miners' Museum in the former headquarters of Consol's Miller's Creek Division. The museum serves as a community center with special programs and exhibits. Often the facility is utilized by the local tourism agencies as they transport literally thousands of Loretta Lynn's fans into the town. Another facility operated by the society is Rucker Park. The park features playground equipment, a picnic shelter, and a retired railroad caboose. The park is open free of charge to the general public.

During the first full weekend of each August, the society holds the Annual Van Lear Town Celebration. The first town celebration was held in 1985 to commemorate the 75th anniversary of the first commercial coal to depart Van Lear by rail. The annual festival includes many events and draws huge crowds to the community.

The Van Lear Volunteer Fire Department (VLVFD) is another progressive organization that benefits all of Van Lear. The department provides fire and rescue services for Van Lear and surrounding areas. They maintain a modern, well-equipped fire station with highly trained firemen. In addition to their duties, the VLVFD also serves the area in a number of community service programs. Perhaps as important as anything is the pride the group inspires each time the citizens see Van Lear written in gold letters on the department's well-maintained fleet.

Van Lear's future is uncertain, but the recent trends toward the development of coal-based synthetic fuels and other alternative energy sources may hold the key to a more productive time. With the proper leadership, Kentucky could be at the forefront in providing clean and efficient fuels for the domestic market. Van Lear and other former company towns could see an economic resurgence as their remaining resources are tapped or as support industries are established throughout Eastern Kentucky. We can only hope that business and government leaders make the right choices in the near future and put not only Van Lear but the entire nation on a road to fiscal prosperity.

One

JOHNSON COUNTY, KENTUCKY

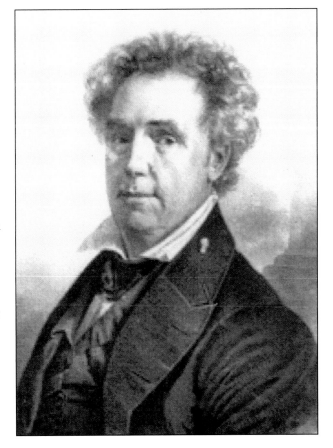

Johnson County was formed from parts of Floyd, Lawrence, and Morgan Counties by legislative action on February 24, 1843, and effective on April 1, 1844. It was named for Col. Richard Mentor Johnson, a famous soldier and politician from Kentucky. Johnson served as vice president of the United States under Martin Van Buren. In addition to Kentucky, the states of Iowa, Missouri, and Nebraska also have counties named for him. (Courtesy of the U.S. Congress.)

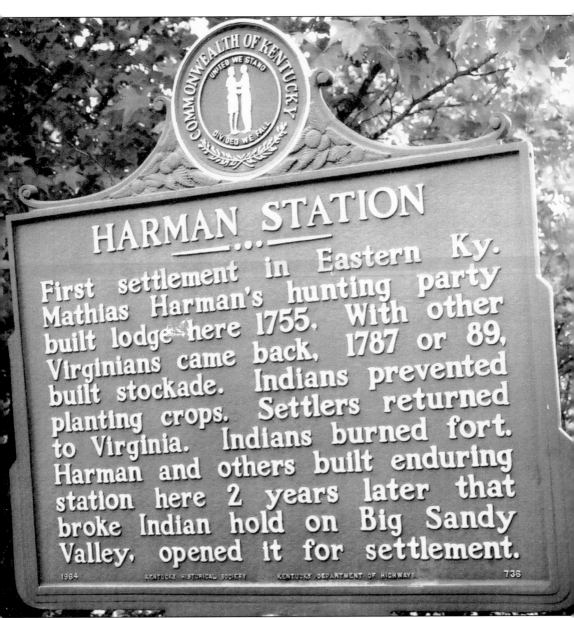

HARMAN STATION

First settlement in Eastern Ky. Mathias Harman's hunting party built lodge here 1755. With other Virginians came back, 1787 or 89, built stockade. Indians prevented planting crops. Settlers returned to Virginia. Indians burned fort. Harman and others built enduring station here 2 years later that broke Indian hold on Big Sandy Valley, opened it for settlement.

1964 KENTUCKY HISTORICAL SOCIETY KENTUCKY DEPARTMENT OF HIGHWAYS 736

This marker stands near the former site of Harman's Station just inside Johnson County near the mouth of John's Creek. Harman's Station is considered the oldest English-speaking settlement in Eastern Kentucky. The station was founded by Capt. Mathias Harman. The blockhouse was a small log structure that could provide the early hunters and settlers a safe haven in time of native unrest. The entire section of bottomland on which the station stood became known as Blockhouse Bottom, and the name remains to this day. It is a well-established fact that Daniel Boone and his son Nathan spent the winter of 1796–1797 in the home of Samuel Auxier Sr. at Blockhouse Bottom. Today Bert T. Combs Airport sits on the former location of the station. (Photograph by Danny K. Blevins.)

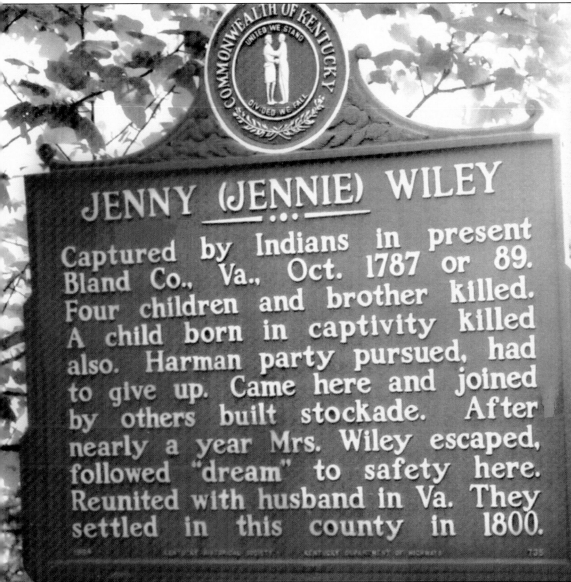

JENNY (JENNIE) WILEY

Captured by Indians in present Bland Co., Va., Oct. 1787 or 89. Four children and brother killed. A child born in captivity killed also. Harman party pursued, had to give up. Came here and joined by others built stockade. After nearly a year Mrs. Wiley escaped, followed "dream" to safety here. Reunited with husband in Va. They settled in this county in 1800.

This marker is also located at Blockhouse Bottom. It relates a brief account of pioneer heroine Jenny Sellards Wiley. Jenny and Thomas Wiley made their pioneer home in Virginia at Walker's Creek. On a journey into Kentucky, Mathias Harman and his group of hunters skirmished with a band of natives. During the fight, Harman killed the son of a Cherokee chief. In an act of revenge, the Cherokees attacked the Wiley cabin, mistaking it for the Harman abode. They killed four of Jenny's children and her brother. The pregnant Jenny and her smallest child were taken into captivity. This child and the one she was carrying were eventually killed as well. Jenny endured about 11 months of captivity. Quite accidentally, her path led her to the Levisa Fork opposite the Blockhouse Bottom, where she was rescued by Henry Skaggs. (Photograph by Danny K. Blevins.)

The county seat of Johnson County is Paintsville. The second oldest settlement in Eastern Kentucky, it was originally called Paint Lick Station because of the Native American paintings that used to adorn the trees and cliffs along what is now called Paint Creek. Paint Lick Station was founded by Col. John Preston. The first charter for the city was granted in 1834. The current charter was issued by the legislature in 1879. Today the city of Paintsville has a population just over 5,000. Most of the businesses are retail outlets, restaurants, or other service-oriented establishments. The city is served by an excellent fire department, police department, and EMT service. The old city hall is shown above. (Photograph by Danny K. Blevins.)

Two

A Dream Comes True

John Caldwell Calhoun Mayo was born in Pike County, Kentucky, on September 16, 1864. He was eldest child of Thomas Jefferson and Mary Elizabeth Leslie Mayo. John C. C. Mayo received his early education in the common schools of Johnson County. Later he attended Millersburg College at Millersburg, Kentucky. It was during his time at college that he developed an interest in geology and mineralogy. Upon returning to Johnson County, he became a teacher. One of his teaching assignments was at the Lower Miller's Creek School, near the mouth of Sorghum Hollow. (Author's personal collection.)

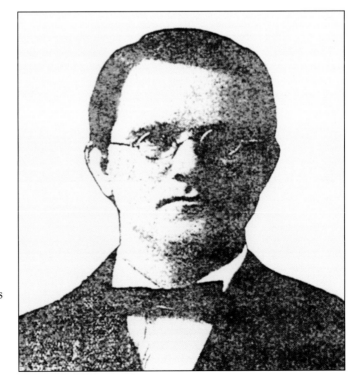

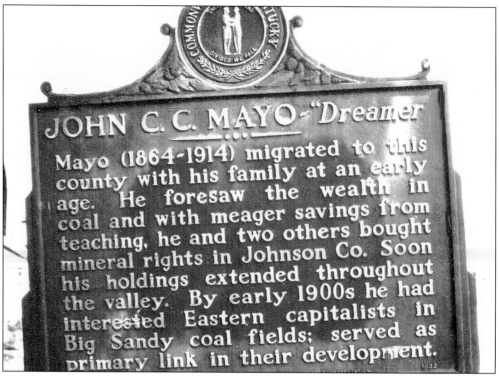

JOHN C. C. MAYO - "Dreamer

Mayo (1864-1914) migrated to this county with his family at an early age. He foresaw the wealth in coal and with meager savings from teaching, he and two others bought mineral rights in Johnson Co. Soon his holdings extended throughout the valley. By early 1900s he had interested Eastern capitalists in Big Sandy coal fields; served as primary link in their development.

This marker stands on Third Street in Paintsville. John C. C. Mayo was a great dreamer and a doer as well. He dreamed of the great wealth that was to be had if the coal industry were established in the Big Sandy Valley. He suffered many hardships, but with the help of a few faithful friends, he held on to his dreams. Mayo amassed great holdings of property and mineral rights. The device that made his acquisitions possible was the controversial broad-form deed. He had the 40-room mansion shown in the photograph below built between 1905 and December 1912. Mayo died on May 11, 1914. He was entombed on a hill near his mansion. (Photographs by Danny K. Blevins.)

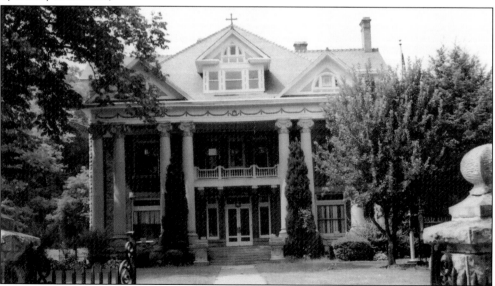

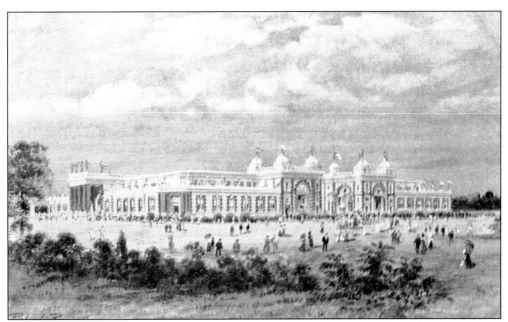

The Jamestown Exposition was a world's fair held from April 26 to December 1, 1907, to commemorate the 300th anniversary of the founding of the Jamestown colony. The exposition was held at Hampton Roads near Norfolk, Virginia. John C. C. Mayo had two carloads of Miller's Creek coal transported to this grand event. This postcard shows the Mines and Metallurgy Building at the Jamestown Exposition. (Author's personal collection.)

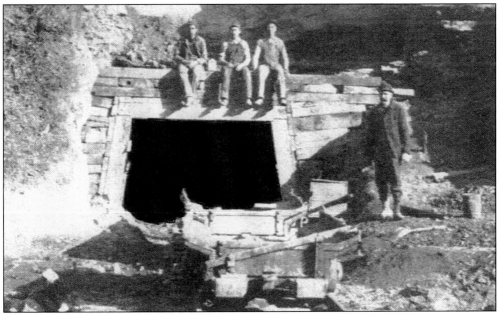

This is possibly the opening near Wolfpen Branch where John C. C. Mayo had coal removed to send to the Jamestown Exposition. Since the railroad did not yet extend to Miller's Creek, Mayo had the coal hauled by animal-drawn carts to Stafford, Kentucky, and then by train to Jamestown, where it was fashioned into a house of coal. (Courtesy of the VLHS.)

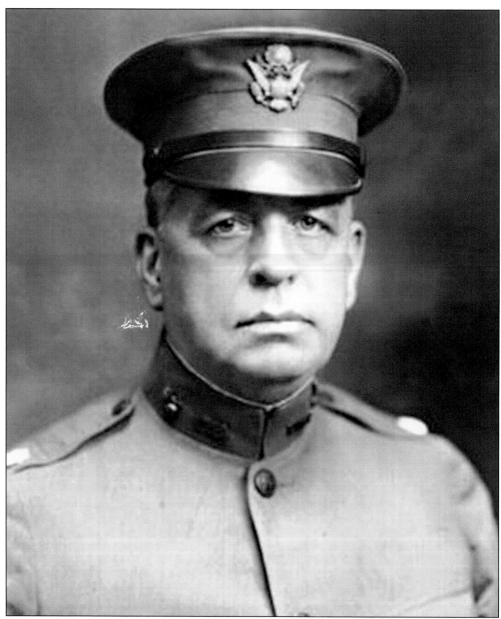

Clarence Wayland Watson was born in Fairmont, West Virginia, on May 8, 1864. Watson served as the president of the Consolidation Coal Company from 1903 to 1911 and again from 1919 to 1928. It was during his first term that Consol purchased the coal properties along Miller's Creek. He was also chairman of the company's board of directors from 1911 to 1919. Upon the death of U.S. senator Stephen B. Elkins of West Virginia, Watson was appointed to serve the remainder of his term, from 1911 to 1913. During March 1918, Watson was commissioned a lieutenant colonel and served in France with the American Expeditionary Forces during World War I. While overseas, his term as U.S. senator came to an end. Watson ran in the election of 1918 but failed to retain his seat. Later still, Watson became the president and chairman of the Elk Horn Coal Company. The town of Wayland in Floyd County, Kentucky, is named in his honor. Clarence W. Watson died on May 24, 1940. (Courtesy of the U.S. Senate Historical Office.)

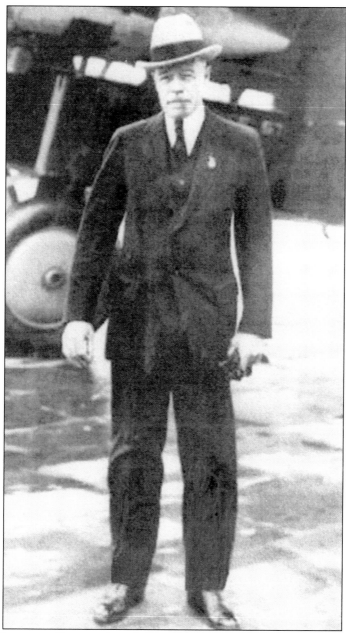

Van Lear Black was a millionaire from Baltimore, Maryland. He owned interests in a number of large corporate enterprises. Van Lear Black served as a director of the Consolidation Coal Company from 1906 to 1927. It was in his honor that the city in the Miller's Creek Valley was named Van Lear. Black earned his place in history as an early aviation pioneer. He was not a pilot himself, but he was the first paying passenger on an intercontinental charter flight from Amsterdam to Batavia and back in 1927. Black wanted to prove that air travel was a safe and viable way for businessmen to travel. He logged several thousand miles as a passenger and became known as "the Flying Millionaire." Ironically Black was lost at sea, as he apparently fell from his yacht on the night of August 18, 1930, into the dark waters of the Atlantic Ocean. (Author's personal collection.)

Locations of Mine Properties and Offices
of the
Consolidation Coal Company & Subsidiaries
Mid 1930's

Consolidation Coal Company with sales offices in:	Consolidation Coal Company Mine Properties :
Portsmouth, NH Boston, MA New York, NY Baltimore, MD Philadelphia, PA Fairmont, WV Detroit, MI Cleveland, OH Chicago, IL Cincinnati, OH Washington, DC	George's Creek Field, MD Somerset, PA Fairmount, WV Miller's Creek Field, KY Elkhorn Field, KY
North Western Fuel Company *with offices in:*	**Empire Coal Company, Ltd.** *with offices in:*
St. Paul, MN Milwaukee, WI Superior, WI Duluth, MN Minneapolis, MN	Toronto, Ontario, Canada East Windsor, Ontario, Canada Winnipeg, Manitoba, Canada St. Catharines, Ontario, Canada St. John, New Brunswick, Canada

This chart shows the extensive network of mine properties and offices of the Consolidation Coal Company and its subsidiaries in the mid-1930s. The headquarters of the Miller's Creek Division of Consol was located in central Van Lear. The former headquarters building now houses the collections of the Coal Miners' Museum, Icky's 1950s Snack Shop, and the headquarters of the Van Lear Historical Society.

Three

A GLIMPSE OF
A NEW TOWN

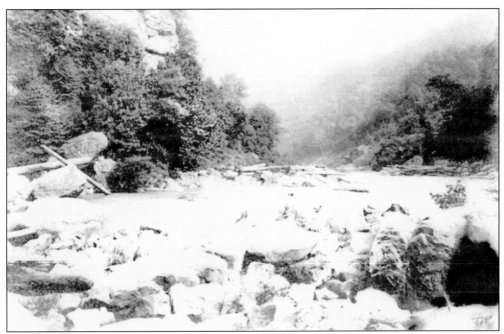

The Levisa Fork of the Big Sandy River forms the western boundary of the community of Van Lear. The river was originally named the Louisa River by Dr. Thomas Walker on June 7, 1750. Walker choose the name in honor of the sister of the Duke of Cumberland. During the period of early settlement, the stream was known exclusively as the Louisa River. This continued until about 1825. The name became corrupted to Levisa, and the original name has fallen from use. (Courtesy of the VLHS.)

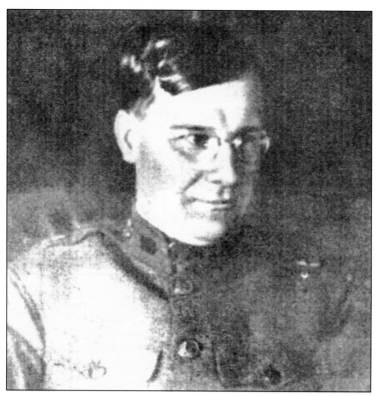

Consol's coal cities had a duel nature. First they were producers of enormous amounts of coal, and secondly they were viable cities. A city would be constructed and everything orchestrated under the watchful eye of a general manager. Once the town was constructed, it could be incorporated as a legally recognized entity. The city could tax and maintain certain aspects of the infrastructure. Of course, Consol would be the largest taxpayer. The photograph above is of John Gordon Smyth, who was one of the early general managers of Van Lear and later of the city of Jenkins, Kentucky. Pictured at right is Edwin Reynolds "Jack" Price, who also once managed Van Lear. (Both courtesy of the VLHS.)

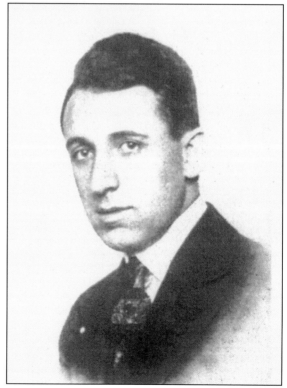

A coal-powered electricity-generating plant is under construction in the western section of Van Lear by the Consolidation Coal Company. The plant was a huge brick structure that incorporated arched windows to provide an aesthetic appearance to a very practical building. The accompanying smokestack was the tallest ever erected in Johnson County. (Courtesy of the VLHS.)

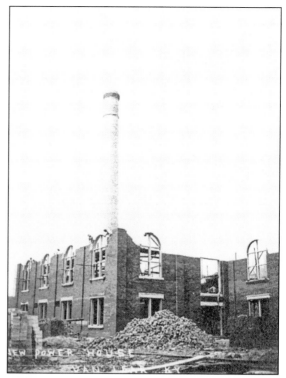

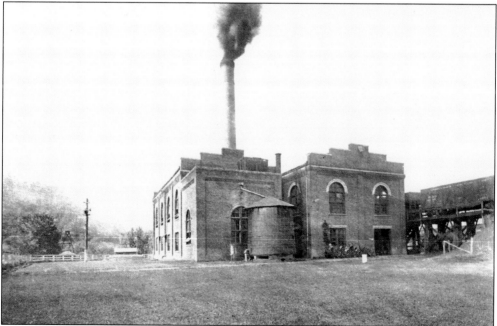

The completed Van Lear power plant is in operation. The facility burned Miller's Creek coal and used water from the Levisa Fork to produce steam. The steam turned the turbine-driven generator and provided power to the communities of Van Lear and West Van Lear. The initial output of the plant was 1,000 kilowatts. Later, the City of Paintsville also received electricity from the plant, and its output capacity was doubled. (Courtesy of the VLHS.)

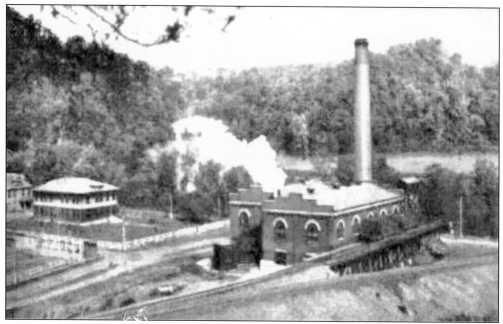

A postcard view shows the Van Lear power plant in operation and the surrounding area. The large two-toned building to the left of the power plant was the main office of the Miller's Creek Division of the Consolidation Coal Company. On Sunday, August 24, 1913, this office burned. The whistle blew at the power plant as a fire alarm, and the company's fire department soon arrived. (Author's personal collection.)

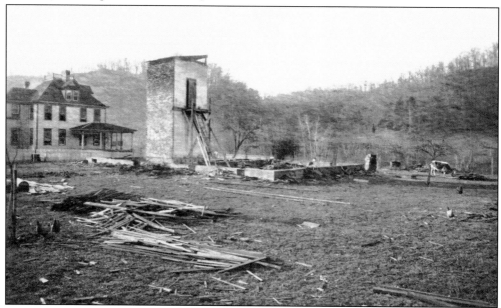

The office workers joined the firefighting crew, and many of the company's important records were saved. The fire was extinguished in time to save the walls of the structure, but the engineers' department was a total loss. The overall damage to the building was deemed too extensive for repair, and the remainder of the building was demolished. Pictured above is a vault that was part of the office building. (Courtesy of the VLHS.)

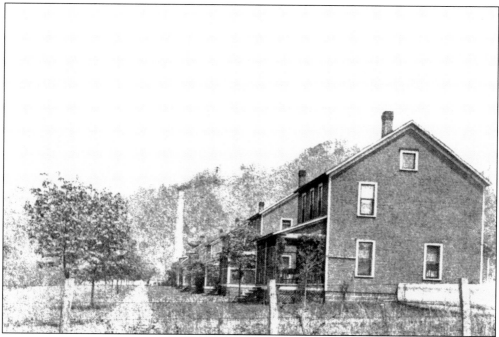

This line of buildings was called River Row. When locomotive engineer William T. Bradley first moved his family to Van Lear, they stayed for a while with Jonathan P. and Mary Bradley Jenkins in their residence at River Row. Jenkins had formerly been the manager of Consol's famous Frostburg No. 7 Mine before being transferred as the superintendent of the Miller's Creek Division. His wife, Mary Bradley Jenkins, was William's sister. The William Bradley family moved up Miller's Creek when a house became available for them. Later they would move a residence of their own at River Row. The second photograph shows the Bradley house at River Row. (Both courtesy of the VLHS.)

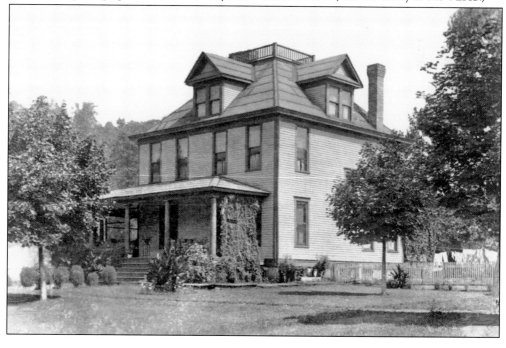

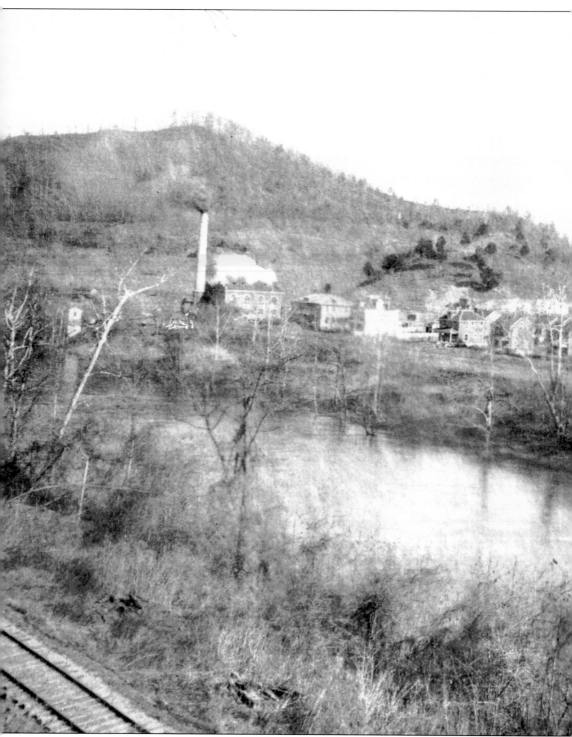

This photograph from 1910 shows the structures of River Row (Powell Addition). One can see in the background to the left a pier of the soon-to-be-completed railroad bridge. The central power plant is in operation, as is evidenced by the billowing smoke and condensation clouds

rising from the facility. Consol's large office building is still standing and operating in this photograph. Notice that the mainline railroad tracks in the lower left corner are a single track. (Courtesy of the VLHS.)

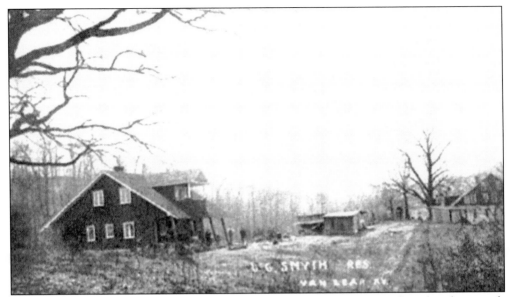

This postcard shows a manager's residence on the top of Clubhouse Hill. When this photograph was taken, the general manager of Van Lear was John Gordon Smyth. He later went to the Elkhorn Division and was so successful there that he became the chief engineer of all of Consol's divisions. Today there are no residences on the hill, and much of the area is occupied by a large cemetery. (Courtesy of the VLHS.)

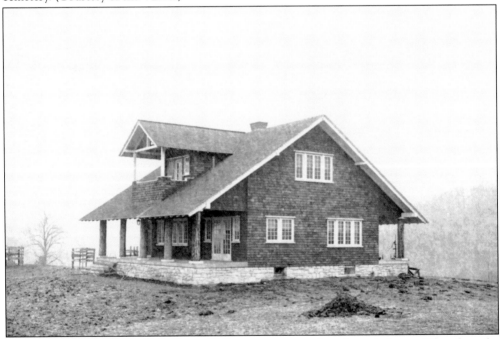

The manager's house on Club House Hill was an arts-and-crafts-style home. The plans for the home originated with a magazine called the *Craftsman*, which was founded by Gustav Stickley in 1901. Stickley worked with architect Harvey Ellis and others to produce house plans for inclusion in his magazine as well as for those who wished to purchase a custom design. (Courtesy of the VLHS.)

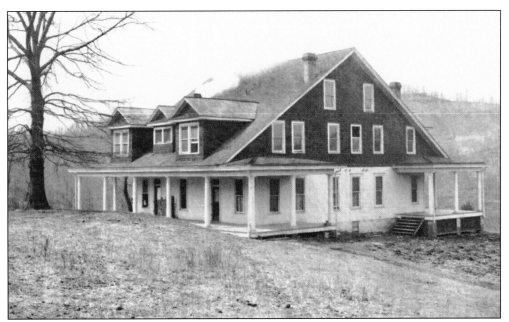

This 1911 photograph shows the original company clubhouse. This building too reflects the arts-and-crafts style, but it is unknown whether it was a Gustav Stickley design. This facility was similar to a bed and breakfast combined with a country club–style lodge. Tennis courts were one of the attractions of the clubhouse. Many banquets and gala social events were held at the clubhouse. (Courtesy of the VLHS.)

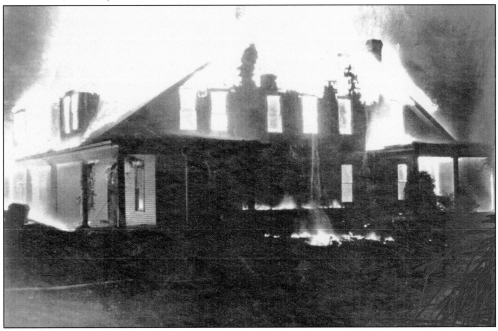

This photograph was taken on January 7, 1922, as the company clubhouse on Clubhouse Hill was destroyed by fire. Today only a number of stone blocks remain to remind one of the stately structure that served as the hub of society for early Van Lear. The next company clubhouse would be built in the much more accessible central section of town. (Courtesy of the VLHS.)

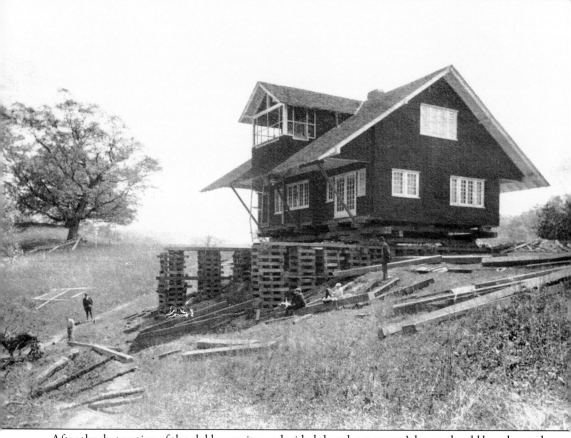

After the destruction of the clubhouse, it was decided that the manager's house should be relocated to the valley below. The account of this attempted move is described in the article, "A Craftsman House Built on a Kentucky Hillside" (*Craftsman* 23 No. 1, October 1912). The house was partially disassembled, and the largest section was raised on cribbing. A steel cable was attached between the house and a tree. (Courtesy of the VLHS.)

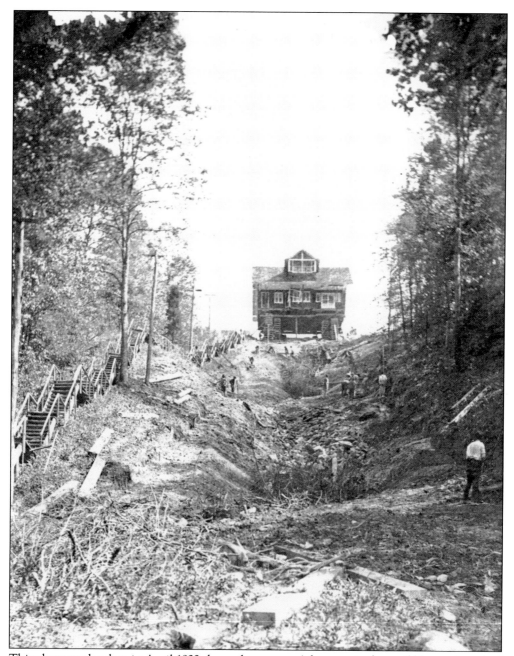

This photograph taken in April 1922 shows the manager's house raised on cribbing and perched on the edge of the hill. Notice the path that has been cleared down the hillside and the network of stairs leading up the hill. This project exemplifies the state of mind of the management of Consol, seeing enormous undertakings as feasible projects. The idea was to very slowly lower the house down the hill by means of the steel cable. (Courtesy of the VLHS.)

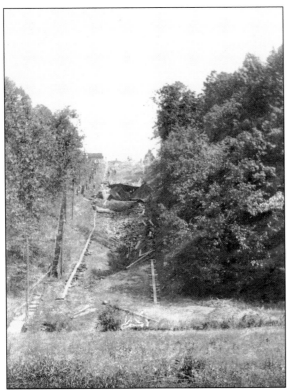

The ill-fated manager's house is seen here lying in ruins. Apparently the weight of the house and its complete furnishings were simply too much for the rigging to support. Everything from dishes to furniture was left in the house. Materials from the wreckage were salvaged and used in the construction of a new manager's residence near the river. (Courtesy of the VLHS.)

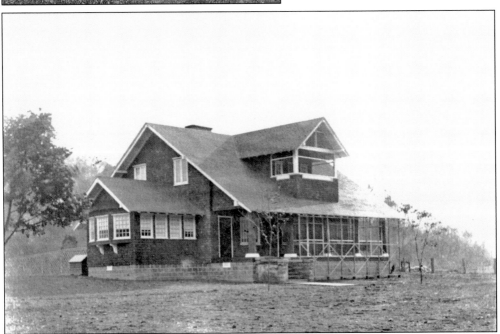

This photograph shows the new manager's residence, built near the river on the west side of town in what most people today call Powell Addition. This name of Powell Addition is misleading, since this area was always inside the established boundaries of Van Lear and was never an addition. This house remained until it burned in 1970. (Courtesy of the VLHS.)

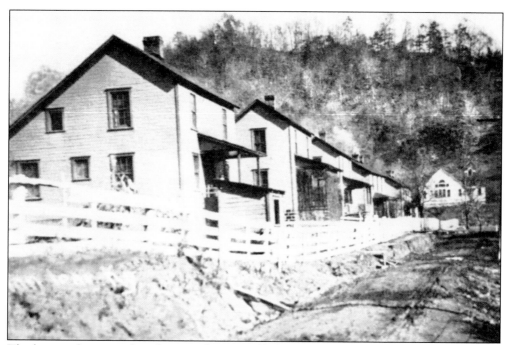

The houses shown in this photograph were called the "boardwalk houses." Across the road from these houses was a playground. At one time, there existed a long wooden walk stretching across the lower end of the playground and extending up toward the railroad track. At the end of this boardwalk was a platform for access to the passenger cars of the Miller's Creek Railroad. (Courtesy of the VLHS.)

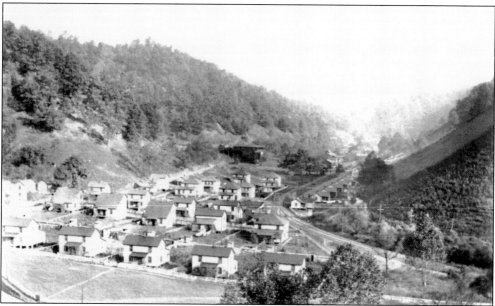

A large group of miners' homes was located across from Webb Hollow (Litteral Branch). The majority of these houses are still in good condition and occupied. The Consol Mine No. 151 can be seen in the background. Notice the overall neat appearance of the yards and hillsides. The company demanded that residences be kept neat and clean. (Courtesy of the VLHS.)

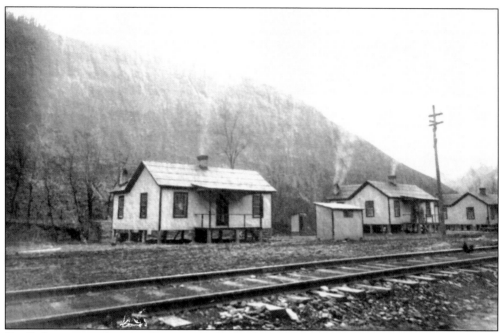

Small three-roomed miners' houses were located close to Mine No. 151 near Bradley Crossing. Most of these homes have fallen into disrepair over the years and are no longer standing. Some of the vacant lots have been fitted with mobile homes. The remaining structures of this row of houses are no longer in a fit condition to be occupied. (Courtesy of the VLHS.)

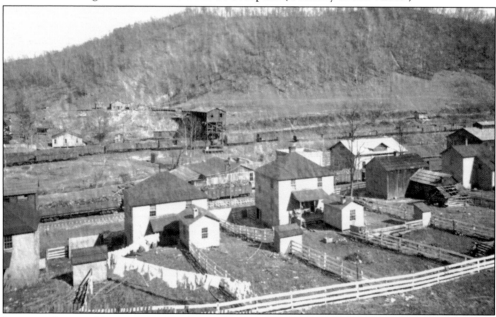

Large coal miners' homes were also located across from Mine No. 151. Several of these houses are still occupied today. Houses in this row have very small front yards because of the location of Kentucky Highway 302. Note the neat, whitewashed fences surrounding each yard. These fences served to provide privacy between neighbors and sometimes to pen domestic animals. (Courtesy of the VLHS.)

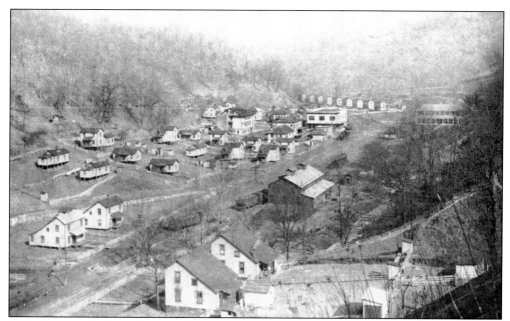

This photograph shows the central section of Van Lear looking east. The huge building near the center of the picture is a company-owned livestock barn. In the background to the left, one can see the main office building of the Consolidation Coal Company's Miller's Creek Division. This office building was constructed to replace the office at River Row that was destroyed by fire. (Courtesy of the VLHS.)

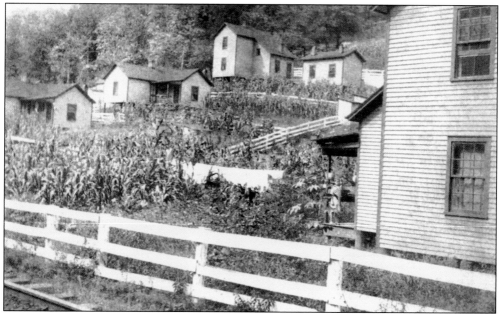

A group of miners' homes was located in the area of central Van Lear, adjacent to Consol's office building. Notice that every residence has its own vegetable garden. The company encouraged everyone to plant vegetables and ornamental plants. Homegrown produce served as an affordable food, while decorative plants served to beautify the community. Garden contests were sponsored by the company for several years. (Courtesy of the VLHS.)

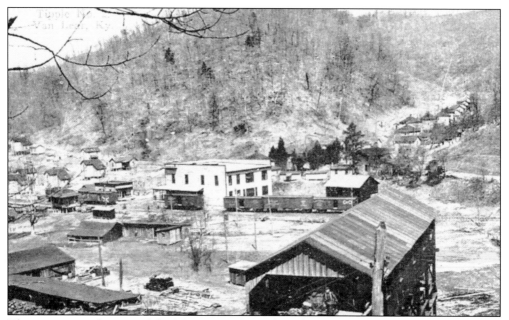

This is a very early view of the Mine No. 152 tipple and central Van Lear. Store No. 1 is the large white structure near the center of this scene. Notice that the company's office had not yet been constructed when this picture was taken. Also note the large number of houses in the right background portion of the photograph. These houses are located in Burgess Branch (also known as Opossum Hollow or Possum Holler). (Courtesy of the VLHS.)

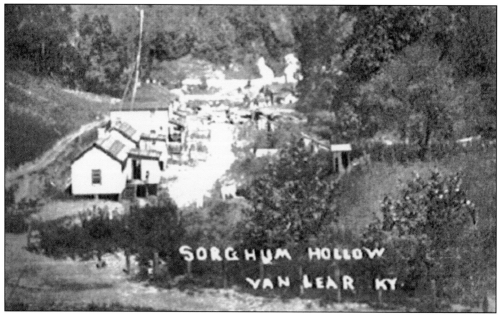

This early photograph shows Sorghum Hollow (previously called Charlie Branch or Kayler Lane). Sorghum Hollow is situated due south of the former location of Mine No. 152. When Kentucky Route 302 was constructed through Van Lear, a ramp was constructed in Sorghum Hollow leading across Richmond Hill and effectively bisecting the hollow. This photograph predates this construction. (Courtesy of the VLHS.)

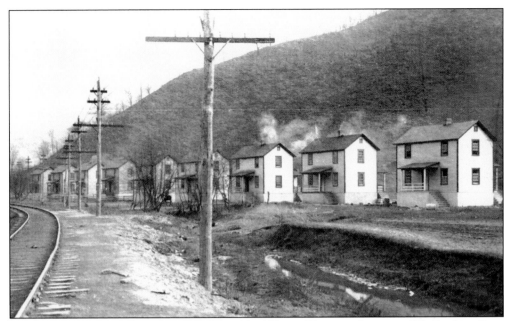

These houses are located just east of the Mine No. 152 site. They were known as Silk Stocking Row. It is typical for mining towns to have a street called Silk Stocking. These were the neighborhoods that contained the residences of the company's bosses and foremen. These fortunate fellows could afford to buy their wives genuine silk stockings. Today it is called Silk Stocking Loop. (Courtesy of the VLHS.)

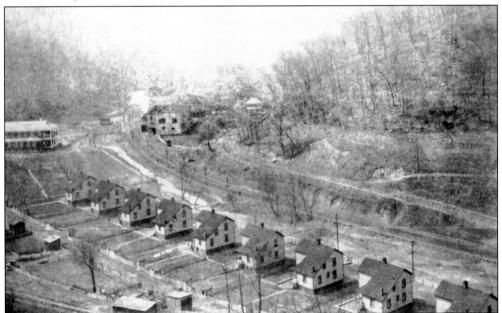

This is another view that highlights Silk Stocking Row. Notice the neat appearance of the spacious backyards. Many families used their backyards for gardening. Several of these homes have been remodeled and are still occupied. To the left is community recreation building, also known as the "Rec" or the "Fountain," and the large white structure near the center of the scene is Consol's Van Lear Store No. 1. (Courtesy of the VLHS.)

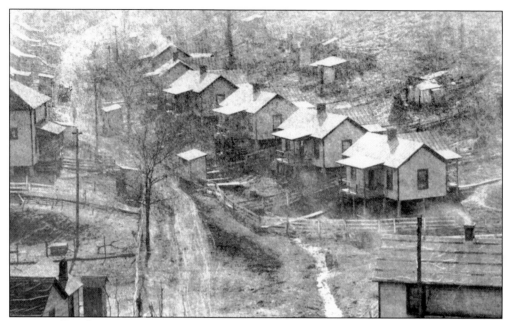

Music Hollow (Music Branch) is due east of Silk Stocking Row. Notice the very muddy roads and crowded conditions in this photograph. The little rectangular buildings seen this picture are outside toilets and wood/coal sheds. (Courtesy of the VLHS.)

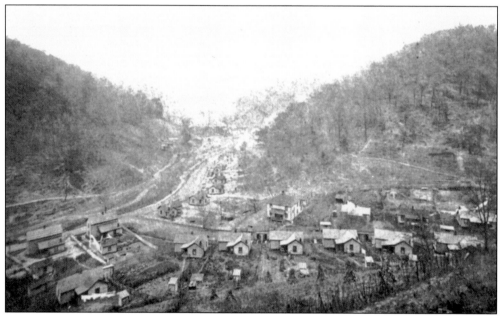

A bird's-eye view shows Music Hollow as viewed from a nearby hill and facing east. The company varied the architecture of the miners' houses, but it was common to build several identical houses in a row, as seen in this photograph. The houses in the background are of the grouping of homes known as Slate Row. (Courtesy of the VLHS.)

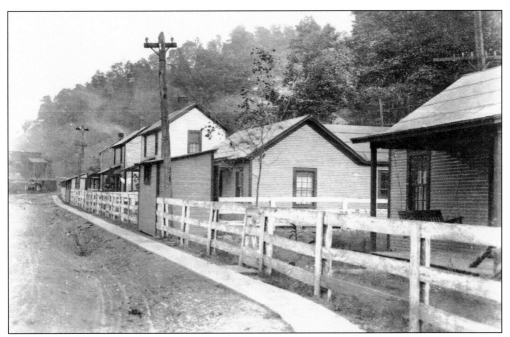

This group of miners' homes lie just east of Music Hollow and are known as Slate Row. Slate is a gray sedimentary rock that is found along with most coal deposits. Slate cannot be burned as fuel, so it is separated from the coal and usually piled in large outside "slate dumps." (Courtesy of the VLHS.)

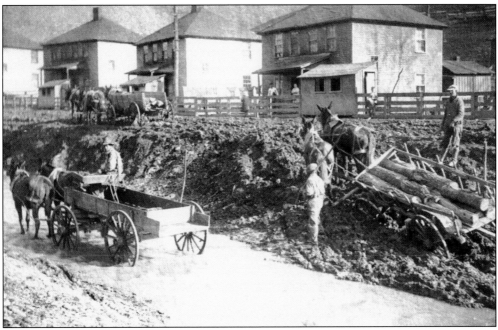

An early photograph shows upper Slate Row. Notice the extremely muddy conditions of the road. Apparently it was better to travel on the rocky bed of Miller's Creek than on some sections of the road. Today a paved Miller's Creek Road follows the same path as this early road. (Courtesy of the VLHS.)

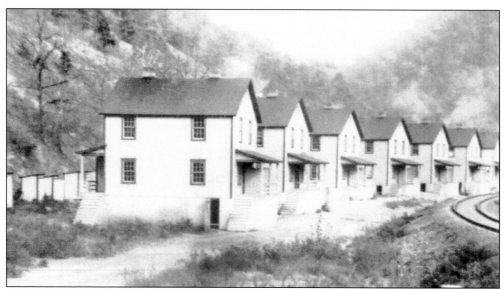

Coal miners' homes are pictured near Mines Nos. 153 and 154 in Wolfpen Branch. Most of these fine-looking homes no longer stand. These residences had little in the way of yard space and sat very close to the railroad tracks. Again notice the privies and coal houses behind the houses. (Courtesy of the VLHS.)

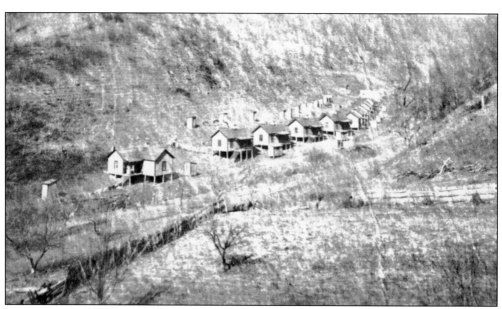

This group of smaller homes is located along a road near Mine No. 154. Today this road is known as Carnation Drive. There is an old slate dump next to the road on the side opposite the houses. When slate is burned, it turns a dull red color and is called "red dog." Red dog was used as a rudimentary road surface on many Appalachian roads for many decades. (Courtesy of the VLHS.)

This was the view from No. 4 Hill looking eastward. The large house on the hill nearest the center of the photograph is known by many as the Max Murphy house. The row of houses at left were located due east of the upper entrance to Wolfpen Branch. Many immigrants and blacks lived in or near the area in the distant background of this photograph. (Courtesy of the VLHS.)

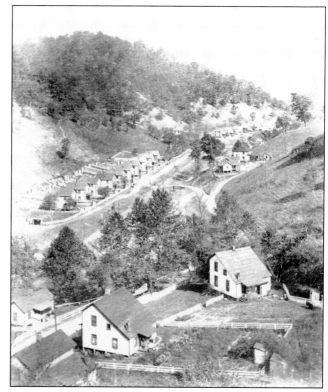

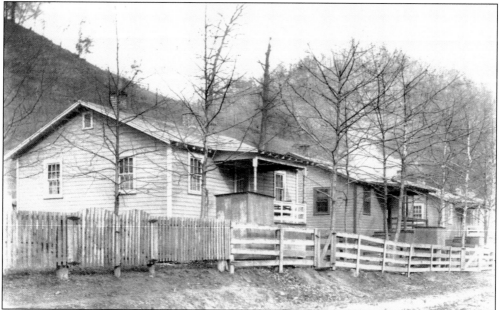

These small houses were in the section occupied by foreign immigrants near St. Casimir's Mission Center. The Miller's Creek mines attracted many people who had recently arrived in America searching for a better life. The diverse racial and ethnic groups included Russians, Slavs, Hungarians, Italians, Irish, and Jews. Blacks from the Deep South were also attracted by the prospect of steady work. (Courtesy of the VLHS.)

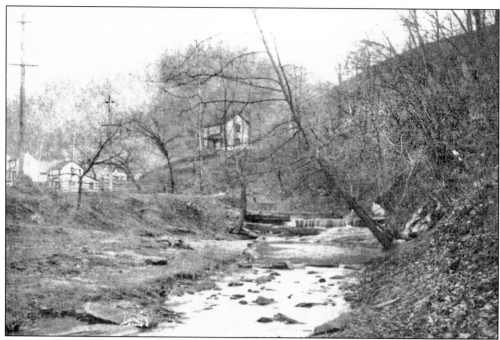

A scene along Miller's Creek shows the site of an old milldam. It is possible that in years past, the creek may have powered several mills. The creek has a more imposing look in early photographs. The Miller's Creek watershed has no doubt been affected by the extensive surface mining that has taken place near the stream's headwaters. The house on the hill is known to many as the Leroy and Maude Murphy home. (Courtesy of the VLHS.)

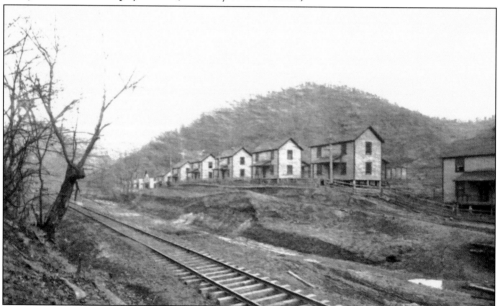

A row of coal miners' homes is located on Hitchcock Loop. These houses are due east of the preceding photograph. Many of these dwellings are still lived in today. Notice that Miller's Creek seems to have been channeled at this point. Whenever the natural course of the creek conflicted with the plans of Consol, the creek was relocated. (Courtesy of the VLHS.)

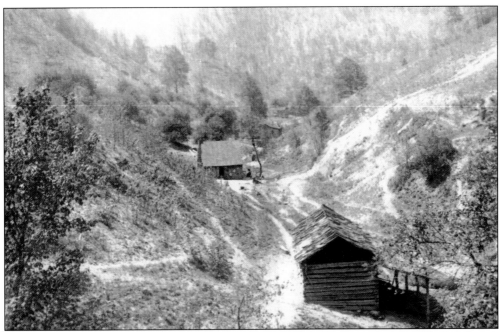

This is the hollow that was known as Wheatfield Branch. This hollow is located off of Hitchcock Loop. This photograph shows what the hollow looked like before the company developed it. The log building in the foreground was probably an animal pen or some other type of utility shed. Notice the primitive shakes that cover the structure's roof. (Courtesy of the VLHS.)

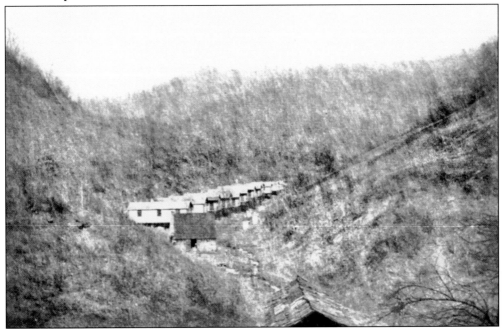

In this photograph, one can see impact that the company had on the hollows it developed. In addition to the two buildings that remain from the previous picture, at least 11 new houses can be seen in the background. These two photographs make it easy to understand the population explosion that occurred in the Miller's Creek Valley. (Courtesy of the VLHS.)

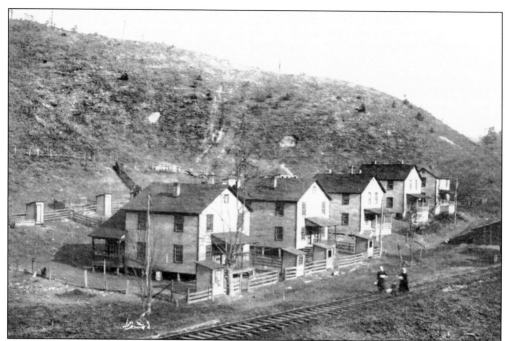

These miners' homes were located in the eastern section of Miller's Creek, in the proximity of Consol's Mine No. 155. Even today, some people refer to this whole section of Van Lear as "No. 5." Some of the structures in the above photograph have two front entry doors, thus signifying that they are double houses occupied by two families. Other two-story houses with only one entry were for single-family occupancy. Notice in the photograph below that the No. 5 Hotel is located at the end of the row. Several of these houses are still standing, and some are occupied. The hotel has been gone for many decades. (Both courtesy of the VLHS)

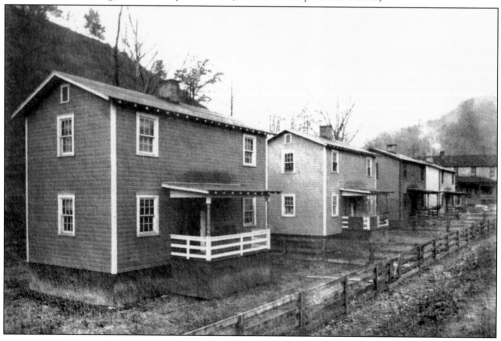

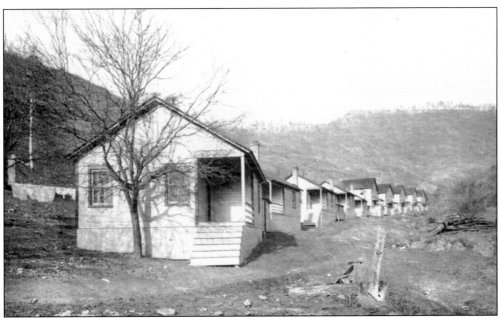

The houses shown in this photograph are in what is today known as Storehouse Hollow. The hollow is called that because of its close proximity to Consol's Store No. 2. On the old insurance plat maps and Consolidation Coal Company maps, this hollow is identified as Butcher Branch. The Butcher family is a very old and established family in Johnson County. It is of little wonder that their name has been associated with the places where they have lived. What many may not realize is that their surname has been anglicized from the original German surname of Metzger. The hollow, now known as Butcher Hollow, lies about 0.7 miles east of Storehouse Hollow. In the photograph below, a group of miners are standing below Storehouse Hollow. The house in the background was the first house seen as one entered the hollow. (Both courtesy of the VLHS.)

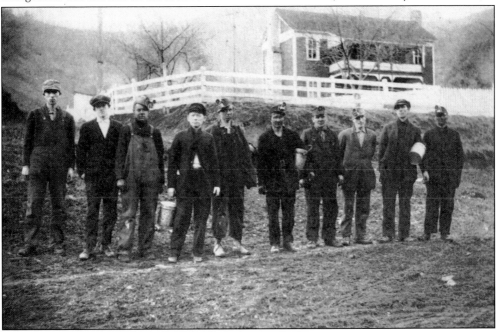

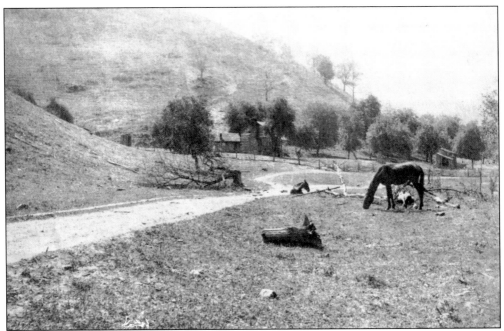

This pastoral view shows the area above where Mine No. 155 would later be located. This scene shows a two-story log cabin in the background and two horses in the foreground. Probably those who lived in this tranquil locale would have never been able to imagine the developments that were occur on Miller's Creek. (Courtesy of the VLHS.)

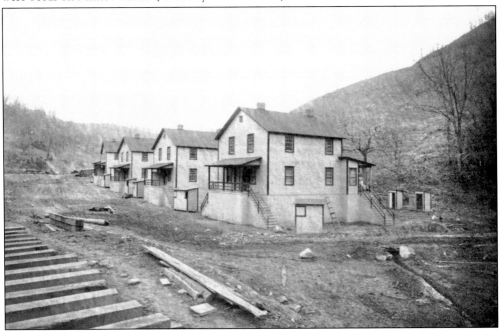

This grouping of homes was located above Mine No. 155. Nothing remains of this neighborhood today. Most would never guess that the now desolate area was once a thriving development. The face of a mining town was always subject to change, as the needs and wants of the company's management dictated the layout of the entire community. (Courtesy of the VLHS.)

Four

A BUSTLING CITY

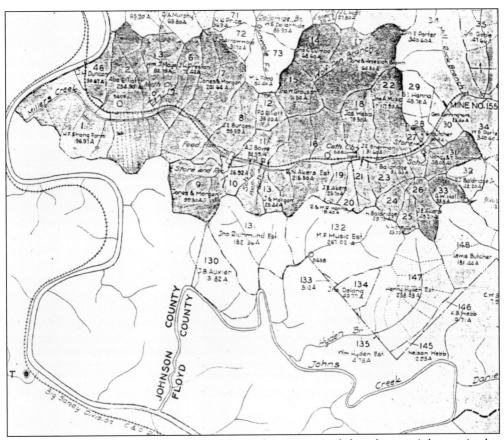

This map was used by the Van Lear City Council in 1919 to redefine the town's limits. At this time, Butcher Hollow and the John's Creek area were removed from the city. The map is one of the best references in existence for identifying the property divisions preceding the arrival of Consol. (Courtesy of the VLHS.)

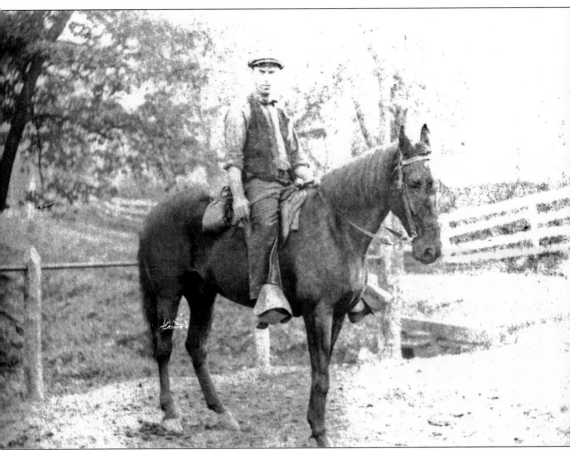

This is a rare photograph of Herbert Queen. He was an early superintendent of construction for Consol. Queen moved from Van Lear to Louisa, Kentucky, in 1921. There he became involved in several business ventures, including Queen and Sammons Company, the Eastern Kentucky Lumber Company, the Coca-Cola Bottling Company of Louisa, and the Big Sandy Building and Loan Association. He was also a member of the Louisa Board of Education. On April 1, 1931, Herbert Queen was on a business trip in West Virginia when he and a fellow businessman were offered a drink of "ginger ale" by the proprietor of a garage. Unknown to the two men, the garage owner was playing an April Fool's prank. They were given what the man thought was a drink laced with mineral oil. Instead, he apparently chose the wrong bottle and mixed a toxic cocktail. Queen was dead in a matter of hours. His friend survived for two days before succumbing. Herbert Queen was survived by his wife, Elizabeth White Queen, and nine children. (Courtesy of the VLHS.)

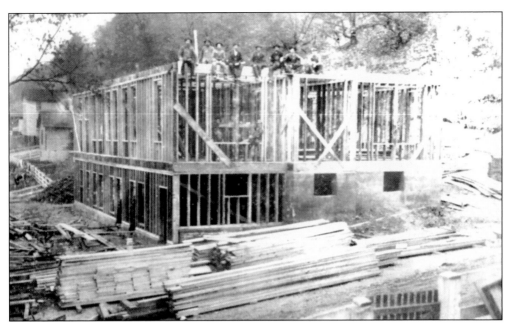

This photograph shows the construction of Consol's large office building near the mouth of Burgess Branch. This structure was built to replace the office that had been destroyed by fire at River Row. It served for many years as the hub of the city. In addition to housing Consol's Miller's Creek Division, it has also housed city hall, the post office, and several businesses. (Courtesy of the VLHS.)

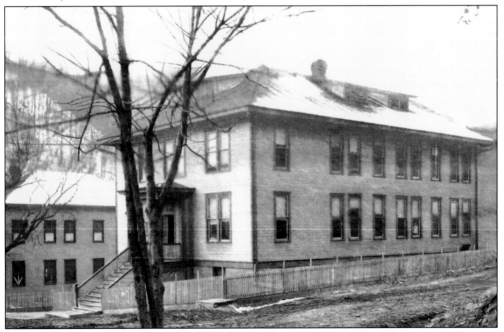

This wintertime scene shows the completed office building as seen from the mouth of Burgess Branch. Like most houses, the office building was surrounded by a picket fence. Notice the muddy road conditions. The road in the bottom right corner of the photograph is listed on many maps as Main Street. (Courtesy of the VLHS.)

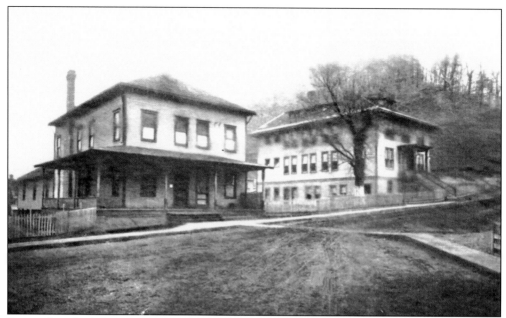

Pictured to the left is the community center, and to the right is Consol's office building. The community center housed several shops and organizations over the years. According to Howard Sparks, the community center was once the location of the post office, a lodge hall, barbershops, and other businesses. He remembered once seeing an orchestra composed totally of redheaded ladies perform at the community center. (Courtesy of the VLHS.)

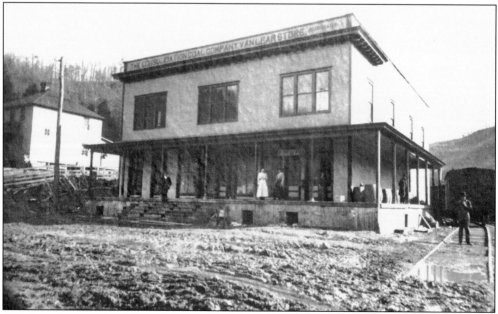

This is a photograph of Consolidation Coal Company's Van Lear Store No. 1. The store was centrally located on the same street as the company's office building. The store had its own railroad side track so that stock could be delivered via freight cars. It was divided into several departments, ranging from grocery items to clothing and furniture. This photograph is an early one, as the front steps were wooden. (Courtesy of the VLHS.)

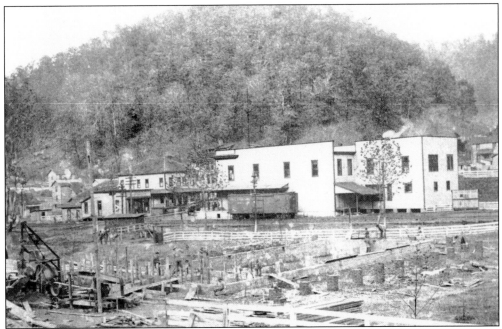

Consol's Van Lear Store No. 1 is shown with a large new annex added to its rear. A freight car is parked next to the store, as it has been used to deliver stock. Across from the store and at the end of the street is Consol's meat market. In the foreground, the foundation is being laid for the Rec. (Courtesy of the VLHS.)

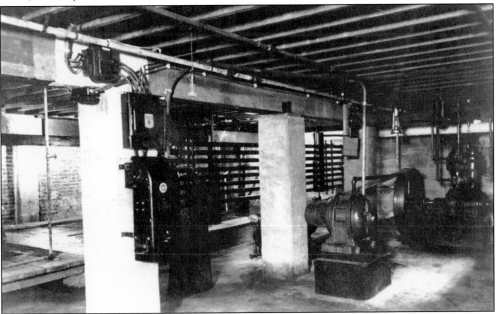

In the basement of Store No. 1 was a complete ice plant. Ice was produced to accommodate the residents who owned iceboxes in the era preceding home refrigerators. The neatness and the use of conduit mark the professionalism of those who installed the ice-making system. The many floor joists seen in the upper portion of this photograph support the floor of the main section of the store. (Courtesy of the VLHS.)

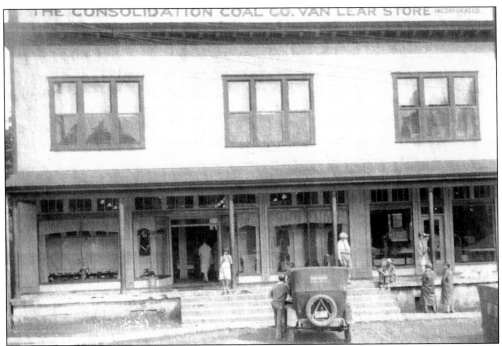

These two photographs were apparently taken within a matter of minutes. Notice that the wooden steps have been replaced by concrete steps. Early automobiles are parked in front of the store. Then, just as now, a nice car was not only good for utilitarian purposes but also served as a status symbol. At this time, it would not have been unusual to find many people still traveling on horseback or walking. The local train line also provided passenger service. (Both courtesy of the VLHS.)

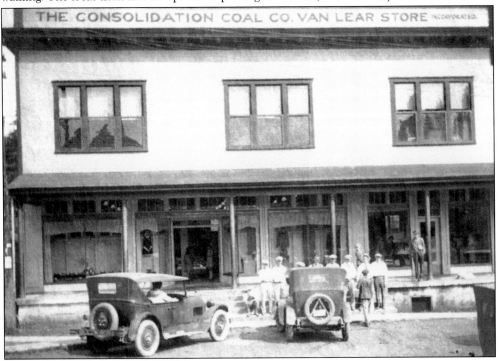

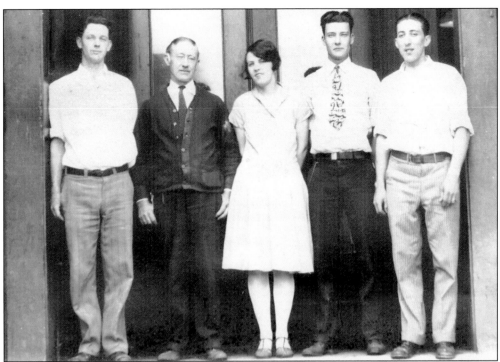

The first photograph shows some of the employees of Consol's Van Lear Store No. 1. From left to right are unidentified, Manford Bayes, Bridgett McCoart, Chester Rice, and Roy VanHoose. In the photograph below is the store's shoe department. Notice how the store is designed with customer service in mind. Items were generally stored neatly on shelves or displayed in cases. Sales personnel would be there to serve customers, rather than customers serving themselves. (Both courtesy of the VLHS.)

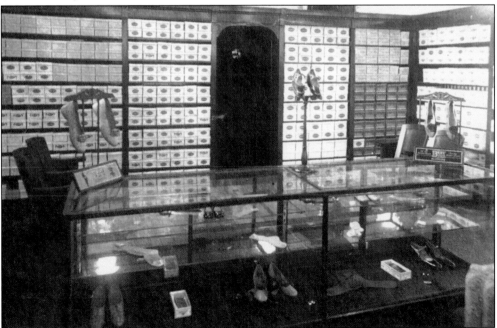

The photograph above shows Consol's Van Lear Store No. 1 as seen looking across Miller's Creek from the Fountain Bottom. The large square-looking section on the rear of the building is an annex. The addition of this section allowed the store to expand the amount of merchandise it carried. In the second photograph is the very appealing interior of the store's annex. Again everything was displayed in assigned locations. All around the display area were spacious aisles that allowed several customers the opportunity to shop at the same time. The high ceiling with its glossy wood looked more like an alpine lodge than a small-town store. (Both courtesy of the VLHS.)

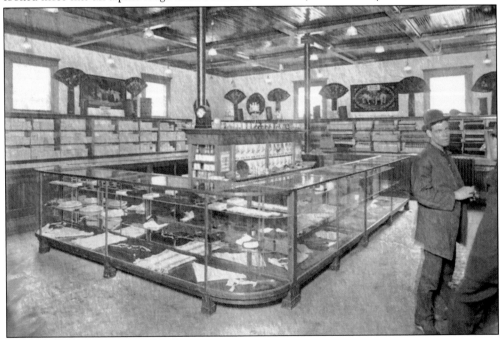

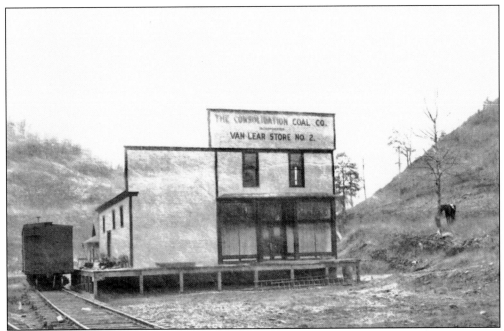

This photograph shows Consol's Van Lear Store No. 2. This store was constructed in the vicinity of Mine No. 155 to accommodate the miners' families in the eastern section of Van Lear and thereby ease the load of the overworked crew at Store No. 1. The No. 2 store is commonly called the No. 5 store, because of its being close to Mine No. 155 (also known as "No. 5"). (Courtesy of the VLHS.)

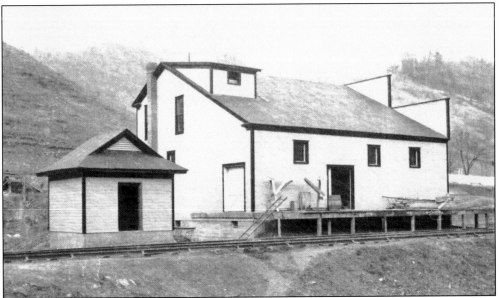

This photograph shows Van Lear Store No. 2 being constructed from across Miller's Creek. The small building at the rear of the store was a small icehouse. After Consol sold Van Lear, a number of proprietors have operated the store, including Abe Goble, John C. Spriggs and Angie Spriggs Collins, Oval "Red" and Rhea Music, Danny E. and Phyllis Wells Blevins, and Herman and Patsy J. Webb. (Courtesy of the VLHS.)

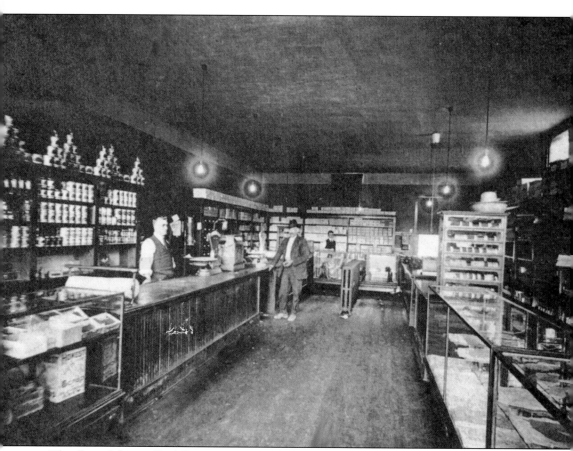

The Consolidation Coal Company's Van Lear Store No. 2 was not as large as Store No. 1, but it was well stocked with the necessities of life. In this photograph, the Hughes brothers mind the store from behind the counters. John Hughes (foreground) was the manager at the time of this photograph. One Saturday night in October 1914, Store No. 2 was robbed. Two men broke into the store, stole the cash register, and carried it into the nearby woods. The cash register contained $328 in cash and checks. The next day, Johnson County sheriff George W. Spears came to investigate. On the following Tuesday, two men were arrested for the crime and lodged in a Paintsville jail. The men were identified as Charles Music and Will Moore. Will Moore was from Louisville. (Courtesy of the VLHS.)

Again, to alleviate the strain on the two large company stores and to better serve the population, another store was built. This photograph shows the small commissary built in Wolfpen Branch. In later times, the structure was used as a church and was known as the Little Mission Church. Today the building still stands but is not being used. (Courtesy of the VLHS.)

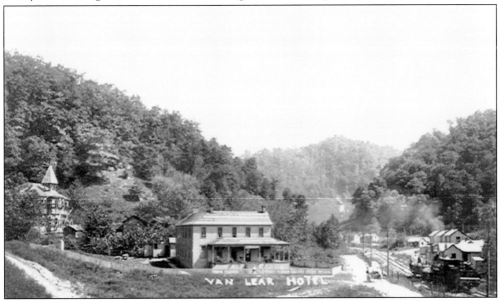

This is an early view of one of the hotels in Van Lear. The hotel is situated in the center of the photograph. In the background to the left is the Van Lear Central School. This hotel sat at the mouth of Schoolhouse Hollow. Temporary housing was often a necessity for a number of people in the bustling city of Van Lear. (Courtesy of the VLHS.)

The hotel at Schoolhouse Hollow was operated for many years by Lou Verna (Akers) Colvin. Lou Verna Akers was a Johnson County native. She was married first to Charles Clark, a native of Canada. They had two children: Bertha Padget Clark and Emma Sizemore Clark. Charles Clark passed away, and Lou Verna later married Tom Colvin. Tom and Lou Verna were the parents of three children: Arthur Colvin, Johnny Colvin, and Virginia Ruth Colvin. Shown in the photograph are Lou Verna and Tom Colvin. Later the hotel was run by Mr. and Mrs. Malcolm Collins Sr. and still later by the Burnette family. Sadly no trace of the hotel remains. (Courtesy of Margaret Davis Arrowood.)

The above photograph shows another hotel in the proximity of Mine No. 155. The hotel was situated right before Consol's Van Lear Store No. 2. It was within walking distance of Mine No. 155 and the school on Peavine Branch (Peavine Hollow). The hotel was mentioned in the May 1, 1922, issue of Consol's *Mutual Monthly Magazine*. According to the magazine's reporter, one resident described the hotel as "an ideal building, situated in an ideal location and under ideal management." In the photograph below are Cicero and Hattie Petery, who once managed this hotel. (Both courtesy of the VLHS.)

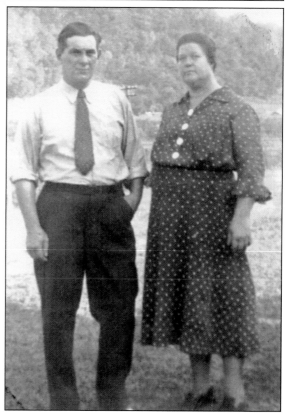

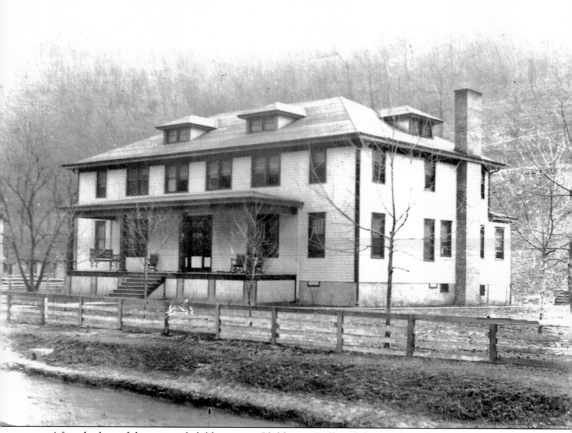

After the loss of the original clubhouse on Clubhouse Hill and the pending closure of Mine No. 152, it was decided that a new, larger clubhouse would be built. This facility would be constructed near the west end of Silk Stocking Row. The new clubhouse would feature a ballroom, a large kitchen, a dining room, and a dozen rooms to rent. These rooms accommodated teachers, salesmen, visitors, or new workers who had not yet been assigned a house to rent. The new clubhouse was the site of innumerable social events and was one of the main focal points of the Van Lear community. The new clubhouse met the same fate as its predecessor and was ravaged by fire in the 1970s. A two-story apartment building now stands in its former location. (Courtesy of the VLHS.)

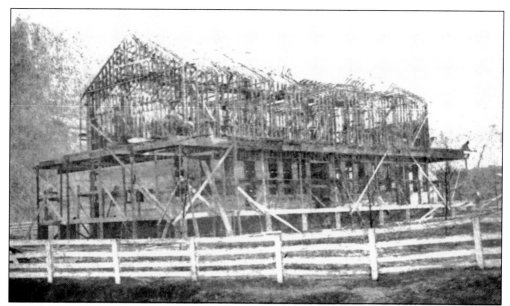

This photograph shows the construction of the Van Lear recreation building. It was built about two years prior to the new clubhouse. The building was to serve the needs of the general population, as a place to hold meetings, put on plays, or just have a good time. (Courtesy of the VLHS.)

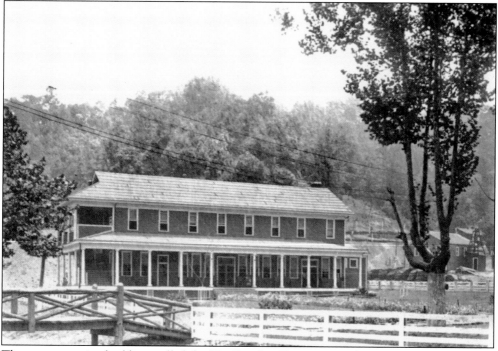

The new recreation building, called the "Rec" or the "Fountain," is shown as it appeared shortly after its construction in 1920. As planned, the facility housed a movie theater, a stage for live productions, an ice-cream parlor, and a billiard hall. Soon the Rec was a prime destination for fun for young and old alike. (Courtesy of the VLHS.)

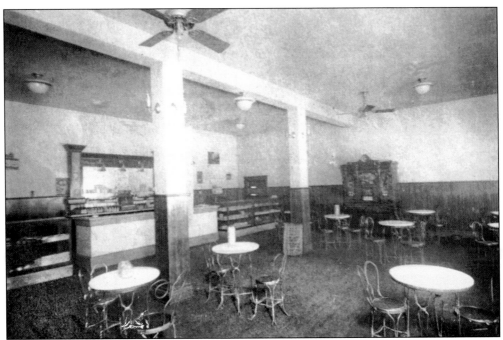

These photographs show two scenes from inside the recreation building. The first is the ice-cream parlor. One can imagine the splendor of young couples on a hot summer evening enjoying their favorite parlor confections. No doubt, people of all ages enjoyed the ice-cream parlor. In the photograph below, some of the gentlemen of the town enjoy a couple of leisurely games of pool in the town billiard hall. Van Lear and the larger company towns stood in stark contrast to the small coal camps operated by less humanitarian companies. Recreational facilities such as these were the exception rather than the rule in rural Appalachian towns. (Both courtesy of the VLHS.)

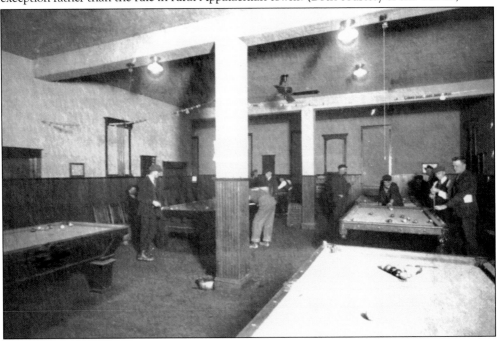

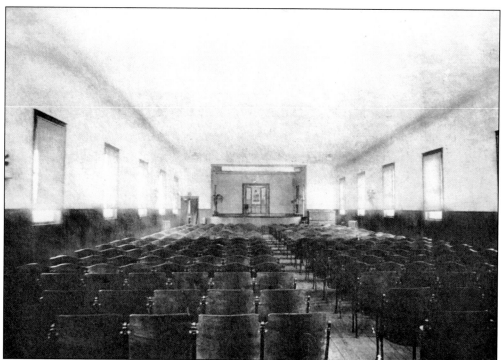

This photograph shows the theater located on the second floor of the Rec. There was a stage at the front of the theater to accommodate live performances. First-run movies opened in Van Lear before theaters in larger cities such as Ashland, Kentucky, or Huntington, West Virginia, received them. In accordance with Jim Crow laws, people of color had to sit in the back row. (Courtesy of the VLHS.)

The stage in the Rec was put to regular use by various civic groups that presented live entertainment as well as by professional performers. A popular source of live professional entertainment during the 1920s was the various lyceum bureaus. One of the best known of the lyceum services was the Redpath Bureau. (Courtesy of the University of Iowa.)

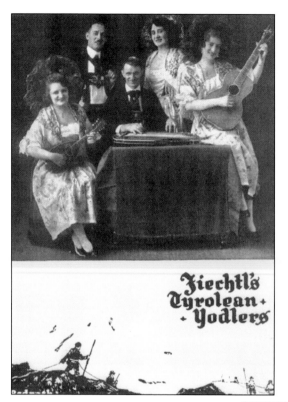

Fiechtl's Tyrolean Yodlers were one of the acts that were booked via the Redpath Bureau. In addition to Alpine yodeling, these performers played instruments, danced, and educated the audience about Alpine culture. Fiechtl's Tyrolean Yodlers performed at the Rec on the evening of Monday, April 16, 1928. This photograph shows a poster of the performers in their stage attire. (Courtesy of the University of Iowa.)

DON'T FAIL TO SEE

'Look Out Lizzie'

The Funniest Comedy of The Season

-AT-

VAN LEAR THEATRE

MONDAY NIGHT MAY 6TH

TIME − 8 P M

ADMISSION 15 & 25ᶜ

AUSPICES

Campfire Girls

This flier advertising a play to be given by the Campfire Girls was typical of the type of entertainment available at the Rec's theater. Sometimes the plays were actually fund-raisers given with the express purpose of raising revenue for the community chest or other designated organizations or causes. (Courtesy of the VLHS.)

G. Cleveland Chambers was an early manager of the Rec. One issue of Consol's *Mutual Monthly Magazine* mentions an incident where Chambers saw the son of George Anderson come into the Rec. Cleveland Chambers winked at some of the bystanders and then told the boy that if he said that he was a Democrat, Chambers would reward him with a box of candy. The little boy screamed out in a very loud voice, "I ain't no Democrat." This type of humor seems rather ironic coming from a Consol publication, since many prominent stockholders of Consol were staunch Democrats. Seated from left to right in the photograph below are G. Cleveland Chambers, Bill ?, Bill Birchwell, and Estill Daniel on the porch of the Rec. Later G. C. Chambers left Van Lear and operated a Maytag business in Pikeville. (Both courtesy of the VLHS.)

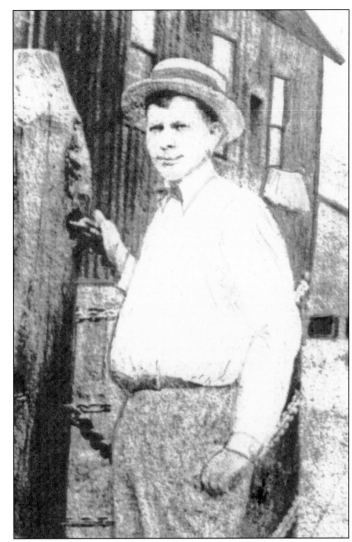

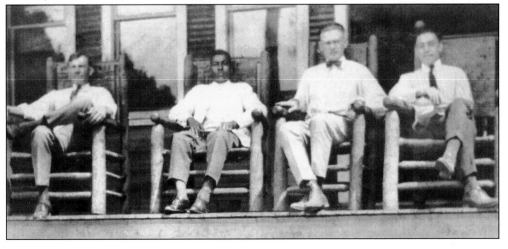

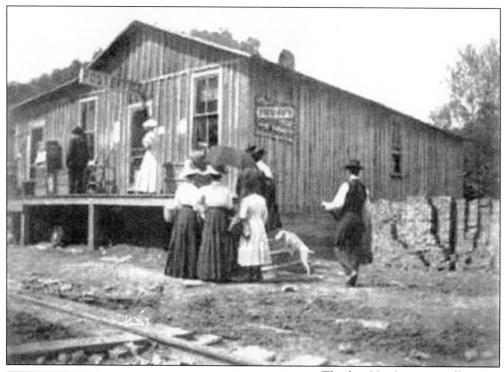

The first Van Lear post office was established in 1909 with Frederick H. King as the first postmaster. This postcard view is believed to be a photograph of this first post office. The current post office is located beside the remnants of Consol's Van Lear Store No. 1. The postmasters, acting postmasters, or officers-in-charge through the years following Frederick H. King were Everett Hitchcock, Martin Luther Price Jr., Elizabeth A. Bradley, Green Conley, Alka M. Gibson, Elbert Warren Beers, Virginia L. Daniel, Louise J. Wills, Katherine E. Short, Sarah E. Delong, Barbara Wilson, Garnetta Rucker, Kenneth Mike Blair, Nickie Thompson, and Kimberly L. Combs. In the photograph at left is Van Lear postal worker Mayme Lafoon. It is interesting to note that the post office was named Van Lear before the city was officially incorporated in 1912. (Both courtesy of the VLHS.)

Five

MINES, MEN, AND MACHINES

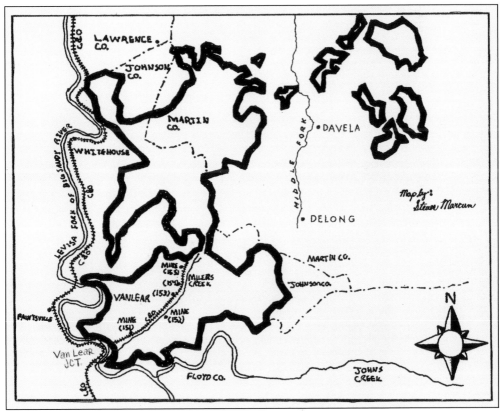

This map shows all of the Consolidation Coal Company's holdings in the Miller's Creek Division. Note the location of Consol's Mines Nos. 151–155 and the course of Miller's Creek, as it basically traces the layout of the Miller's Creek Valley. The map shows the Van Lear Junction, this area surrounding the railroad junction developed into the once incorporated city of West Van Lear. This city's charter was dissolved in 1933. (Map by Steven Marcum.)

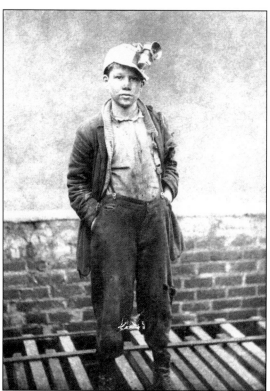

A young Dan Cyrus is shown in the typical coal mining attire of the early 20th century. Laws restricting child labor, as well as other factors, resulted in fewer youngsters being employed in the larger mining towns. Consol urged their mining families to attend school. In some situations, a parent could give written consent for a minor to work for the coal company. (Courtesy of the VLHS.)

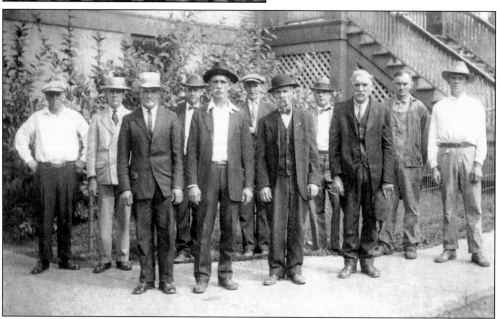

This photograph from around 1922 shows the oldest employees of the Miller's Creek Division of the Consolidation Coal Company. If living today, these fellows would be considered too old for employment by most companies. Certainly they would be considered unsuitable for underground mining, although the mining they did was much more physically demanding than modern mining techniques. (Courtesy of the VLHS.)

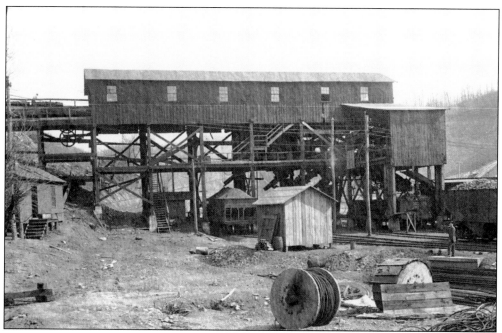

These two photographs are of a mystery mine, Mine No. 150. The existences of Consolidation Coal Company's Mines No. 151 through 155 are very well documented. There are even a few men surviving who worked in these mines. A mention of Mine No. 150 was found in a record of mine samples taken from Miller's Creek mines. It is known that Mayo had coal removed from an opening near Wolfpen Branch around 1906 or 1907. Coal from this opening was displayed at the Jamestown Exposition. Could this early opening have been the beginning of Mine No. 150? Was this mine perhaps renamed? The answer to this mystery is yet to be discovered. (Both courtesy of the VLHS.)

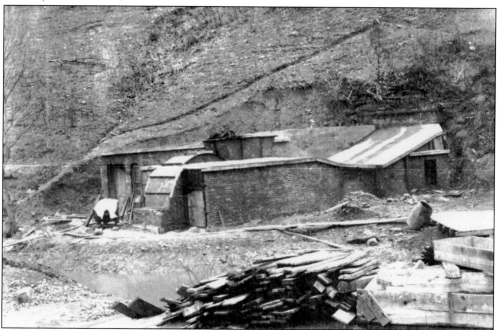

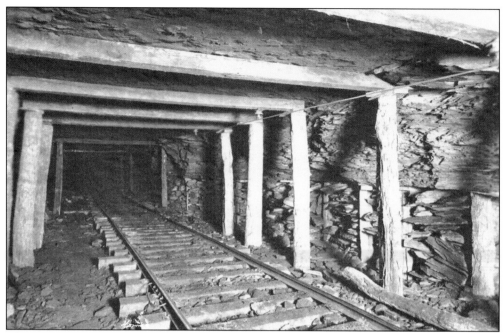

These two photographs show interior scenes from Mine No. 151. Both of these scenes show how wooden timbers were used as roof supports. The most basic method of timbering is simply to trim all of the branches off of trees that have been cut down and cut them to the desired lengths. Inside the mine, one simply places timbers against the each wall of the shaft, and they hold up another timber spanning the width of the shaft and lying against the roof of the shaft. The timbers in the photograph below have obviously been sawmill cut. These milled timbers were installed at the mouth of Mine No. 151 in 1923. In later periods, steel timbers were used. (Both courtesy of the VLHS.)

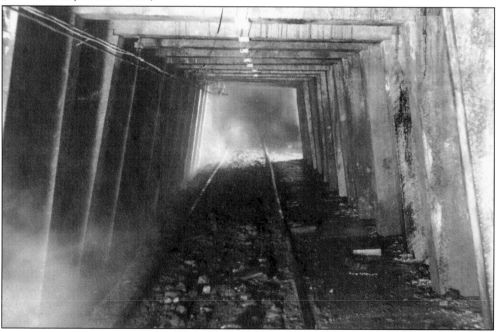

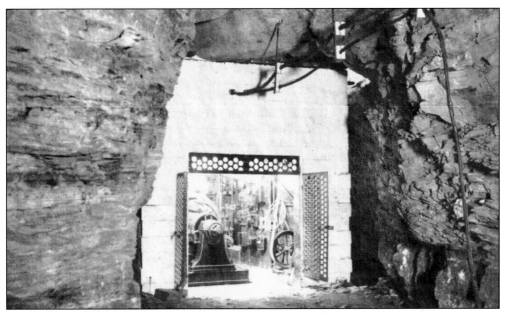

The use of electricity revolutionized the way coal was mined. Coal and other mined materials had been hand-loaded and then removed from the mines by brute force of humans or draft animals. Electricity allowed the use of lights, drills, cutting machines, motors, and other devices. Electrical substations located inside the mines allowed power to be regulated and distributed as needed throughout the interior of the mine. Electrical devices brought about the discontinuation of the use of draft animals inside the mines. The number of miners necessary in work crews also decreased, while their overall productivity increased. A crew of fewer miners could now mine more coal per shift. (Both courtesy of the VLHS.)

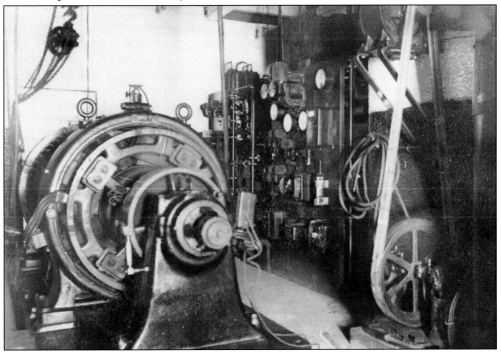

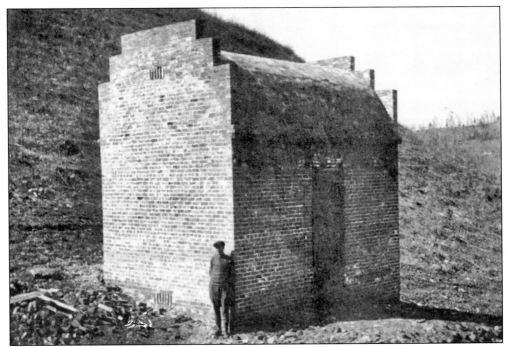

The first photograph is of a common powder house or magazine. Dynamite and explosive supplies were stored in these buildings. A young Jim Kelly of Opossum Hollow crawled into a hole broken out of the bottom of a powder house near his home. Not knowing what was stored above him, he thought it was a good place to hide and smoke cigarettes. Fortunately for Jim, there were no holes in the floor above him. The photograph below shows a close-up view of the Mine No. 151 tipple. (Both courtesy of the VLHS.)

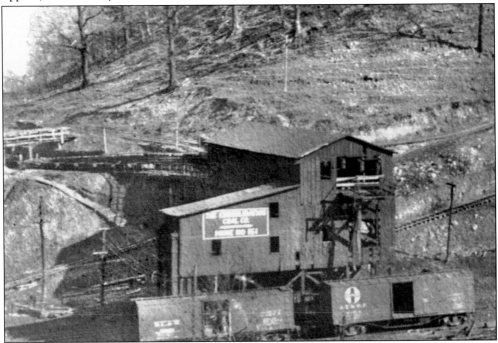

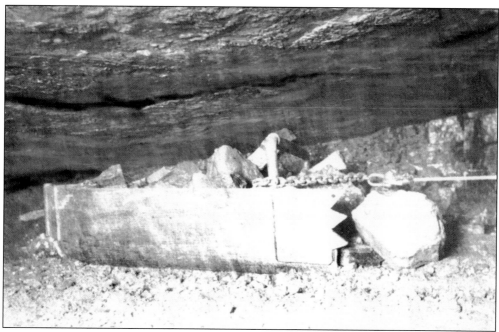

These are photographs of a crew using a Goodman scraper loader inside Mine No. 151. The scraper loader simply used a scraper attached to a winched cable. As the cable was wound, it scraped up coal that had already been brought down from the working face. The scraper was brought up to a shuttle car and emptied. The miners had to help steady the scraper and manipulate the lumps of coal, but it was much easier than loading everything by hand. In viewing the photographs contained in this book, it is important to remember that they show the mines over a period of several decades. Generally speaking, the older the photograph, the more labor-intensive the job. (Both courtesy of the VLHS.)

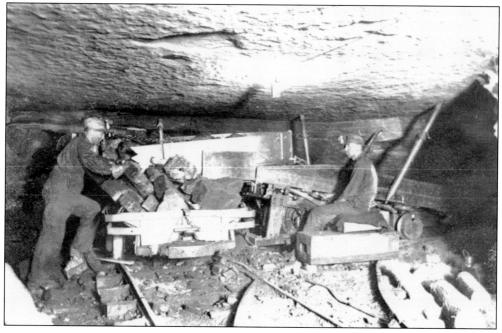

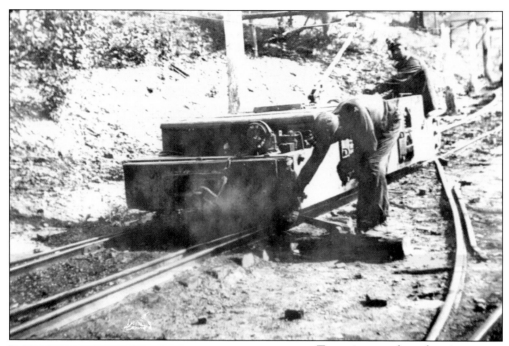

Two miners and an electric haulage motor are shown in this photograph. The electric motor was the workhorse of the electrified mines. These motors pulled loads of coal from the mines, pulled equipment, and transported materials to the working face. Early motors used a power system like trolley cars, with an arm making contact with an overhead cable. Later motors had safer onboard batteries. (Courtesy of the VLHS.)

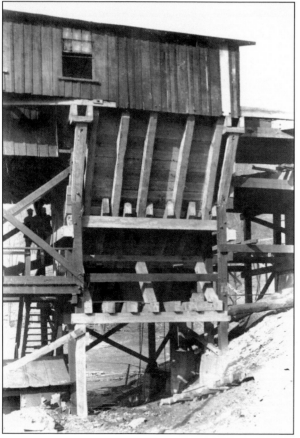

This is the slate disposal bin for Mine No. 151. Removal of slate was a major part of the mining operations. Usually the slate was loaded into hauling cars and dumped into a pile in some nearby location. This slate just stayed where it was put unless it was burnt into red dog and used as road material or in the production of cinder blocks. (Courtesy of the VLHS.)

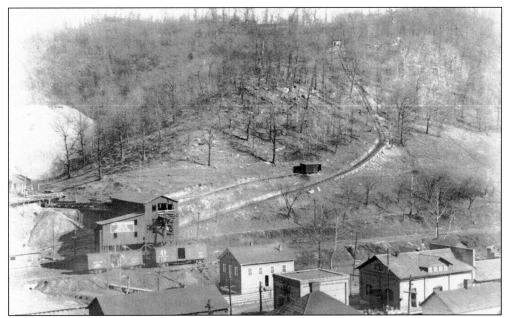

This photograph shows the Mine No. 151 tipple with the slate haul track going up hill on the right. Notice the two large mounds of slate in the background at left. In the foreground, one can see some of the Mine 151 support facilities. In addition to miners, the mines employed a manager, tipple workers, blacksmiths, mechanics, and others who worked together to keep the collieries productive. (Courtesy of the VLHS.)

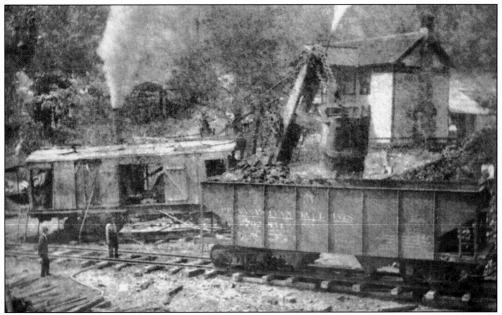

A large steam shovel loads stock coal into a railroad gondola. These shovels allowed the stock coal to be piled anywhere near a colliery's side tracks. This way, the coal did not have use the tipple's loading shoots, nor did it require manual labor to load. These early steam shovels were sometimes used to channel the main creek when the company's plans and the creek's original location came into conflict. (Courtesy of the VLHS.)

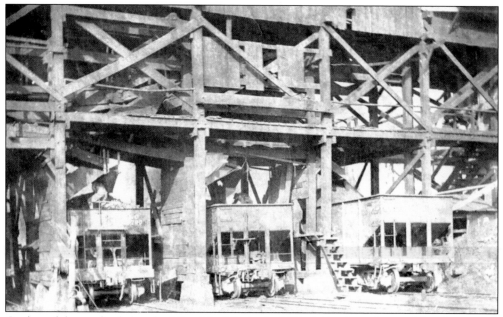

Coal gondolas are loaded at the Mine No. 151 tipple. Miller's Creek coal was sold in three main sizes: nut, egg, and lump. The coal was vibrated along screened devices called shakers that allowed the coal to fall through holes of varying sizes, thus allowing simultaneous loading of all three sizes. (Courtesy of the VLHS.)

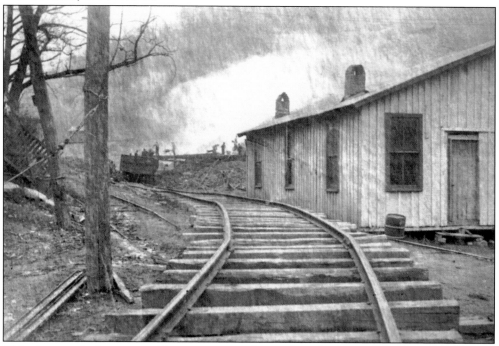

This photograph shows a troublesome scene at the stock coal pile at Mine No. 151. The light-colored cloud rising in the background was due to a stock coal fire. Stock coal was like money in the bank for the company. A substantial fire could mean a great loss of revenue for the mine. This fire occurred in 1917. (Courtesy of the VLHS.)

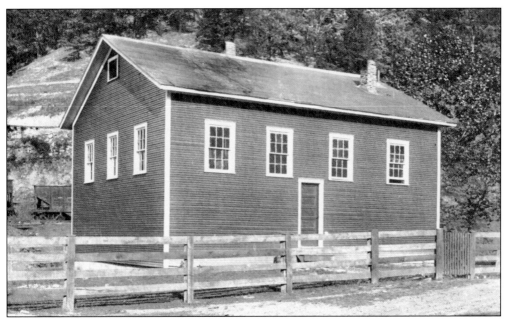

This was the new bathhouse at Mine No. 151 as it appeared in 1920. Upon arriving at the work site, the miners would change out of their street clothes and into their work clothes. After their shift was over, the miners would remove their dirty clothes, shower, and change back into their street clothes. This bathhouse and the one at Mine No. 152 were made from an early theater building. (Courtesy of the VLHS.)

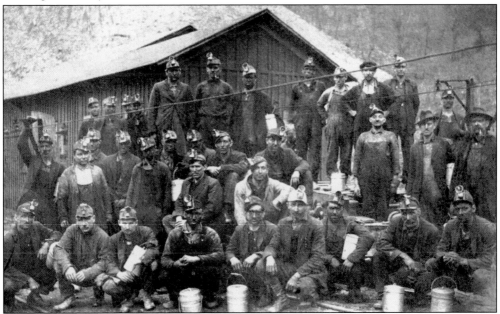

Consolidation Coal Company Mine No. 151's operating crew in 1922 included, in no particular order, the following: brakemen Ervin Baldridge, Ray Lee, Ora Groves, Elbert Perry, Curtis Barber, Rufus Sparks, and Sheridan Dale; Superintendent Jim Cook; motormen Con Daniels, Bill Kretzer, Jack Adams, Emmett Groves, George W. Davis, Melvin Music, and Bill Dixon; and mine foreman Jim Bob Worley. (Courtesy of the VLHS.)

Safety departments and first-aid teams were maintained at all mines. Shown here is the emergency hospital for Mines No. 151 and No. 152. Consol also hired doctors and nurses to provide health care as well as to be available in times of disaster. One early booklet used in recruiting miners listed the monthly doctor's fee as $1 per month for a single man or $1.50 for families. (Courtesy of the VLHS.)

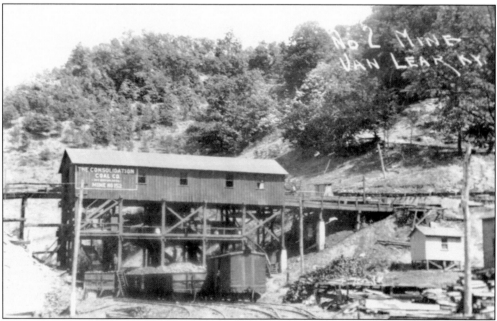

This was the tipple for Consolidation Coal Company's Mine No. 152. The mine was located near the mouth of Sorghum Hollow, occupying the same location as the one-room school where John C. C. Mayo once taught. Notice that in the upper right corner of the photograph it says "Mine No. 2." The mines were commonly referred to simply by the last digit in their assigned number. (Courtesy of the VLHS.)

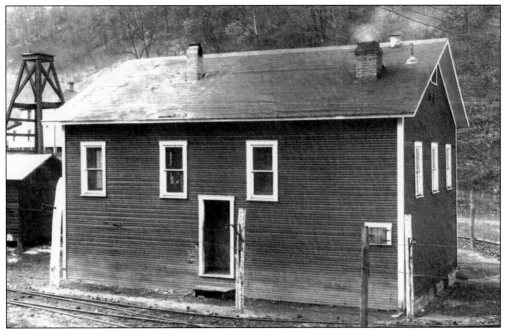

This was the bathhouse for Mine No. 152. Notice how similar it was to the bathhouse for Mine No. 151. This bathhouse was constructed from the remaining half of an old theater building. Perhaps this was the same theater for which Tom Moran was billed a $15 theatre license fee by the Van Lear town board in October 1914. (Courtesy of the VLHS.)

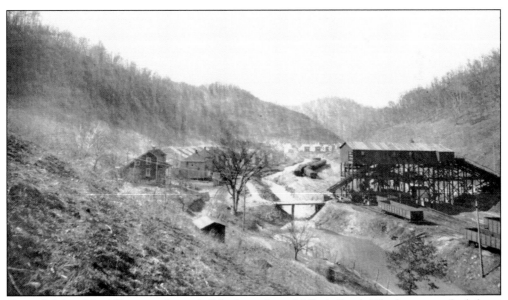

Consol's Mine No. 153 is seen from a hill looking down Miller's Creek. The houses to the left are those of Slate Row. The overall appearance of Miller's Creek in this scene is very different from the way the stream looks today. Miller's Creek ordinarily is a stream that one can jump across in many locations. (Courtesy of the VLHS.)

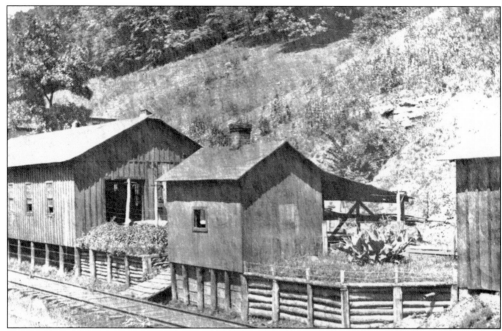

Gardening and beautification of the community were made popular by Consol's annual gardening contests. Who would have ever guessed that a flower garden would be found on the colliery grounds of Mine No. 153? These flowers were no doubt a welcome sight for those who worked in the dirty and noisy environment of a working coal mine. (Courtesy of the VLHS.)

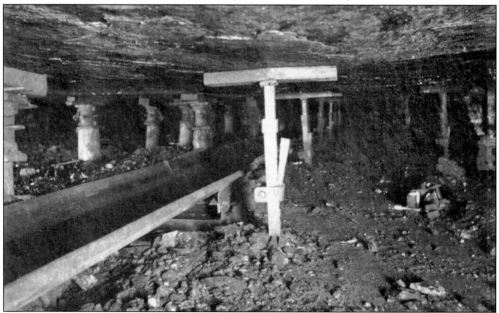

Miners in Mine No. 153 used a technique called longwall mining. Longwall mining is very efficient and involves the total removal of large blocks of coal. A long coal face is worked and a movable line of jacks supports the roof. As the coal face is removed, the roof of the mined-out area is allowed to collapse. In this photograph, the jacks are set before the coal is brought down. (Courtesy of the VLHS.)

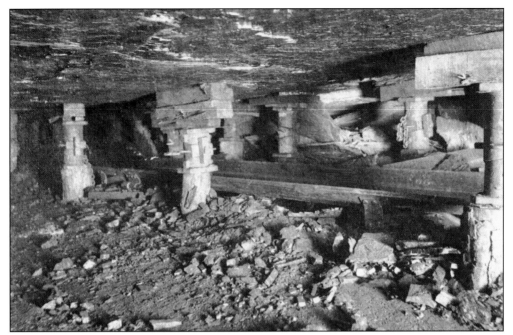

In longwall mining, the long coal face is usually worked by a plough or scrapper that runs along the coal face or it is shot down. In this photograph, the coal has been brought down. Now the coal had to be removed from the area so that the process of moving the jacks and working the coal face further back could continue. (Courtesy of the VLHS.)

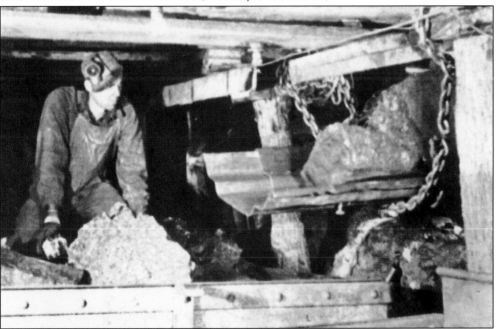

This photograph taken in 1926 shows a miner loading a cart at the end of a conveyor. The coal was then sent to the outside of the mine for processing. In earlier times the miners would load the coal into a cart by hand and then a "bankmule" would pull it out of the mine. The term bankmule refers to mules, donkeys, or horses that were used inside the mines. (Courtesy of the VLHS.)

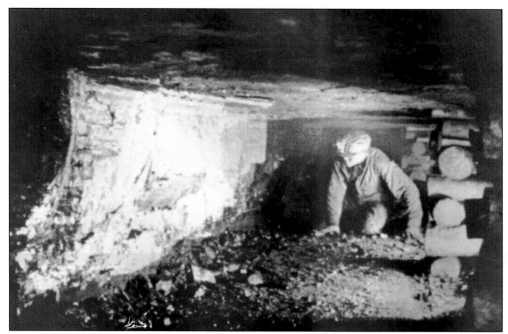

Here one sees a miner in an area where the coal has been removed. Once the coal was removed from an area, the roof was allowed to collapse. This collapsed area was called a "gob area." The roof-supporting jacks had to be moved constantly to support the roof near the working coal face. (Courtesy of the VLHS.)

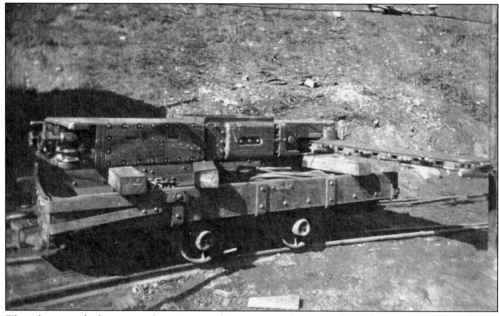

This photograph shows a coal-cutting machine mounted on a coal cart frame. Cutting machines were usually used to undercut the coal before shooting. The gap between the coal seam and the floor would permit the coal to expand and break more efficiently. Essentially the makeup of a cutting machine is very similar to an oversized chainsaw. Some coal would fall because of its own weight after being undercut. (Courtesy of the VLHS.)

Shown in these two photographs are components of the Mine No. 153 slate disposal system. In the shot at right is the massive slate dumping bin. The sheer size of the timbers used in the bin's construction reflects the sturdiness of the structure. In the scene below, the slate disposal track is visible. The slate would be ejected out of the bin and loaded into carts. These carts were pulled up the hill and their contents dumped into a slate dump. Some slate dumps, if left undisturbed, take on the appearance of small hills. When covered with vegetation, they do little to give away the fact that they are man-made mounds. (Both courtesy of the VLHS.)

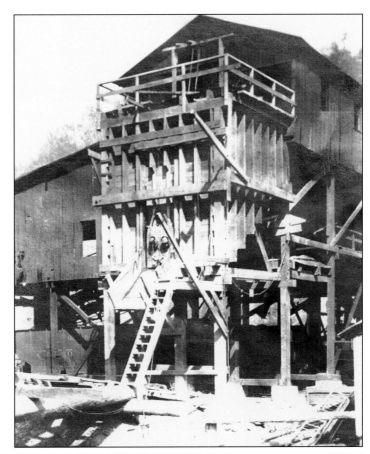

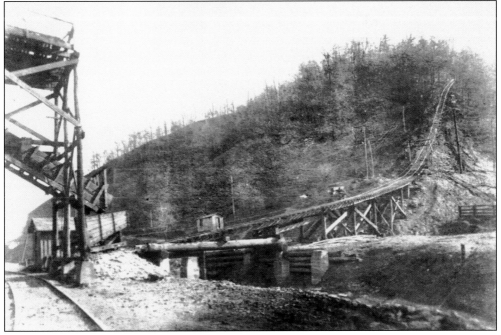

These two photographs were taken at the main office building during August 1927. These men were the best coal loaders in the adjacent Mines No. 153 and No. 154. Pictured in the photograph at left from Mine No. 153 are Bradley Young (left) and John Gaiski. In the photograph below, representing Mine No. 154 are William May (left) and Frank Wetzel. Unlike some of the smaller coal camps, people of all backgrounds were permitted to live and work in the towns owned by Consol. John Gaiski was one of the many foreigners who worked and resided in Van Lear. In a very tragic accident in 1944, the then-62-year-old John Gaiski died as a result of injuries sustained during a slate fall. It was said that Gaiski was planning his retirement at the time of his tragic accident. (Both courtesy of the VLHS.)

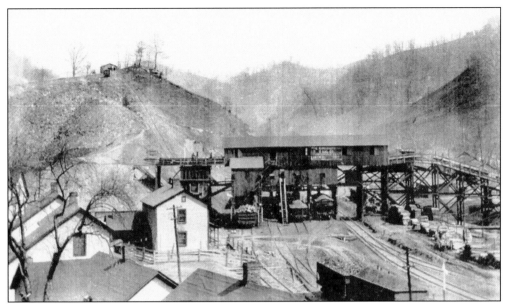

This photograph shows the Mine No. 154 area. It is amazing just how close some of the miners' residences were to the mine. One must wonder how the housewives dealt with the level of dust and noise associated with the tipple equipment and trains. The Van Lear mines often ran three shifts around the clock during times of peak production. (Courtesy of the VLHS.)

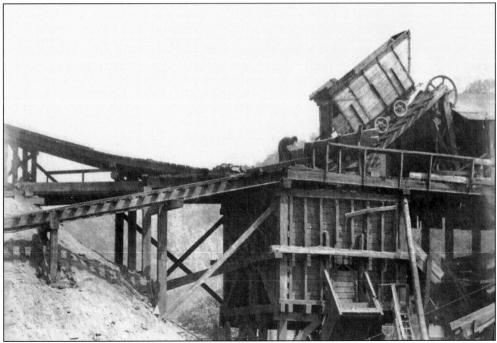

In this photograph, one sees a load of stock coal being dumped into a bin. Often the Van Lear mines would stock coal when they did not actually need to mine so that their workers could continue to have a steady income. During slow economic times, the workers in smaller coal-based communities simply suffered. Notice the size of the coal cart in relation to the tipple worker. (Courtesy of the VLHS.)

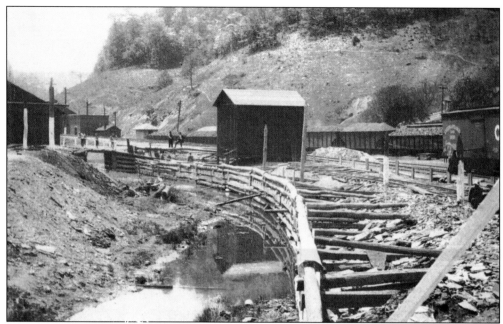

Here is a view of how the natural route of Miller's Creek was sometimes changed. When the creek was in the way of company plans, it was simply relocated. This photograph was taken near the Mine No. 154 area. It is virtually impossible today to walk along the banks of Miller's Creek and see any signs that the creek was sometimes canalled. (Courtesy of the VLHS.)

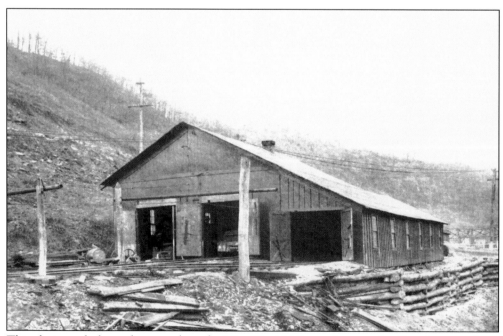

This photograph shows the motor barn for Mine No. 154. Just as its name implies, the motor barn was a building where the haulage locomotives or motors were stored and maintained. In earlier times, draft animals required barns, so these electrical bankmules also required barns. One can see that an addition had been added to the right side of this structure. (Courtesy of the VLHS.)

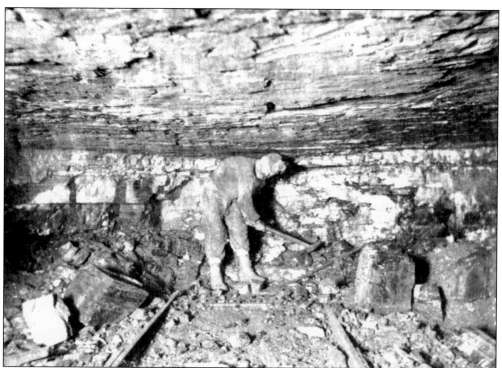

In the photograph above, Pete Perkoski prepares to load coal in Mine No. 154. Van Lear was open to people of all backgrounds, but segregation still existed. In the photograph at right is one of the African Americans who worked in the Van Lear mines. Underground, the Jim Crow protocol was somewhat relaxed, as the black miners were permitted to call their white coworkers by their given names. On the surface, the black miners were still known by their given names, but the whites were referred to as "mister" and their surnames. Sometimes black work crews were sent into the more dangerous sections of the mines while the white workers went to the safer areas. (Above, courtesy of the VLHS; right, courtesy of Bertha Kretzer.)

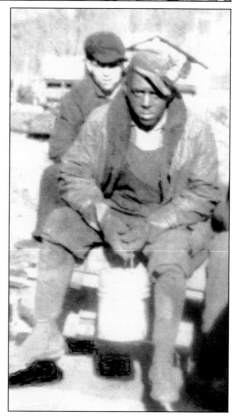

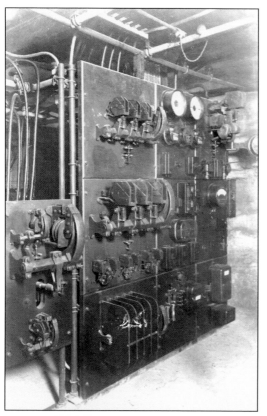

These photographs from 1922 show a newly installed underground electrical substation in Mine No. 154. The substation was installed by Jimmie Borland, a representative of the Westinghouse Company. The neatness of the installation attests to the skills and craftsmanship of the installer. This is especially true when one remembers that this set-up was one-and-a-half miles back from the mine's mouth. Borland no doubt realized how important his job was to the overall operation of the mine. According to a Consol magazine, Jimmie seems to have been a success in his relations with the people of Van Lear, as they were lamenting his having to return home at the completion of his job. (Both courtesy of the VLHS.)

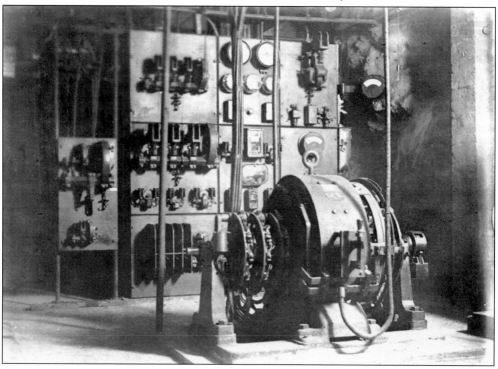

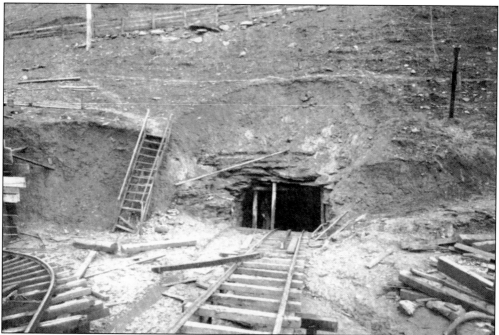

The first photograph shows the original opening for Consolidation Coal Company's Mine No. 155. According to the late Brownlowe Wells, much of this opening was hand-dug. Wells stated that his father, Samuel Jefferson Wells of Odds, Kentucky (Daniel's Creek of the Van Lear area), helped with the digging. In the second photograph is Mine No. 155's temporary tipple. Notice the concrete piers visible in the background. These piers were to support the permanent tipple that was soon to be built. Also of note are the two wooden wagons and the absence of automobiles. The brute force of horses, mules, and oxen played an important part in the initial construction of Van Lear and its mines. (Both courtesy of the VLHS.)

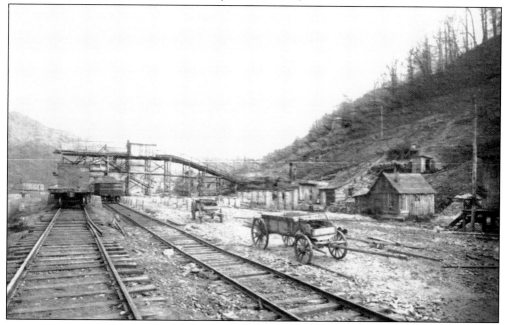

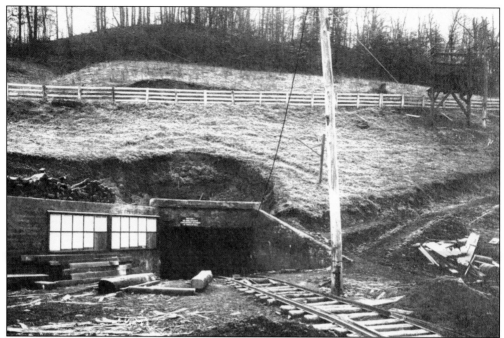

The first photograph shows improvements that have been made to the Mine No. 155 opening. The sign over the opening reads "Notice! No one except employees allowed in this mine." One can easily imagine how tempting an open mine would have been to any young boys that may have been playing in the area. The next photograph was taken in 1914 and shows the Mine No. 155 tipple in operation. This scene is looking up Miller's Creek. The mine's slate dump was located to the left, and the road leading past the mine was on the hill to the right. Today the road runs directly where the tipple sat. (Both courtesy of the VLHS.)

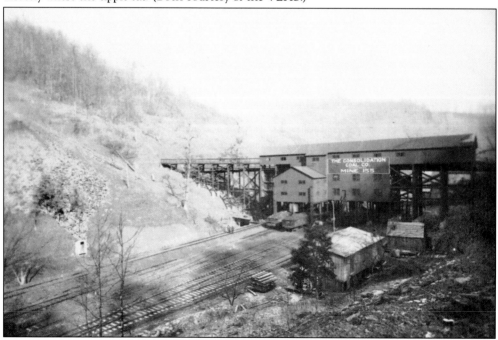

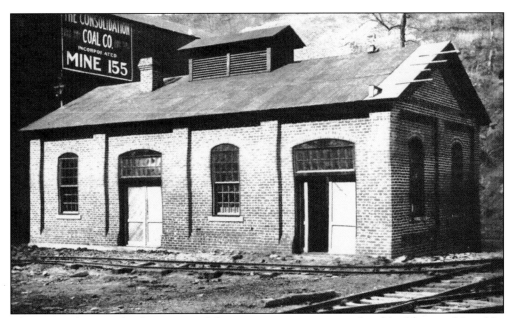

These two photographs show some of the more impressive mine-related buildings at Mine No. 155. The first picture is of the building that housed the mine foreman's office and the blacksmith's shop. The business side of the individual mine would be conducted in the foreman's office, while on-site repairs could be carried out in the blacksmith's shop. In the photograph below is the Mine No. 155 bathhouse. This bathhouse was more elaborate than most of the others in Van Lear. It is a puzzle just why Consol built some of the most important structures in the town from wood, but constructed colliery buildings of brick. Most of the buildings that were the focal points of the community were wooden-framed and have burned over the years. Strangely these impressive brick structures are no longer in existence. (Both courtesy of the VLHS.)

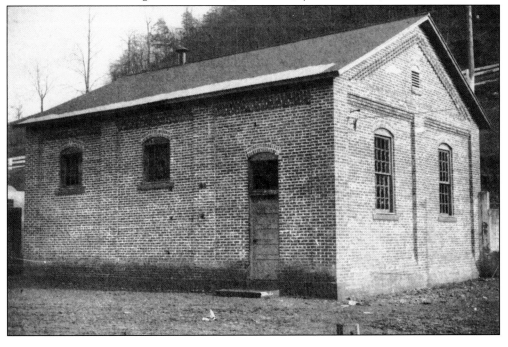

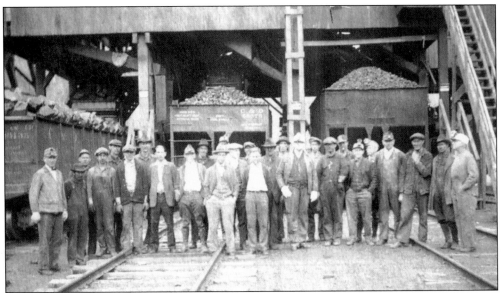

These photographs record a visit of the governor of the commonwealth of Kentucky to Mine No. 155. The governor was William Jason Fields, a Democrat who served in that capacity from 1923 to 1927. Fields was a native of Willard in Carter County, so he was well acquainted with the challenges that faced the workers of Eastern Kentucky. He is probably best remembered for his administration's creation of the Kentucky State Parks Commission. In the photograph taken at the tipple, Governor Fields is the fellow in the white mining cap with his right thumb hanging on his pocket. In the underground scene, Fields is the taller of the two men standing in the back row wearing white mining caps. William J. Fields died at age 79 in Olive Hill, Kentucky, on October 21, 1954. (Both courtesy of the VLHS.)

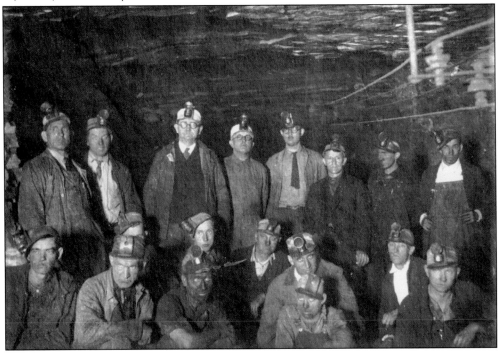

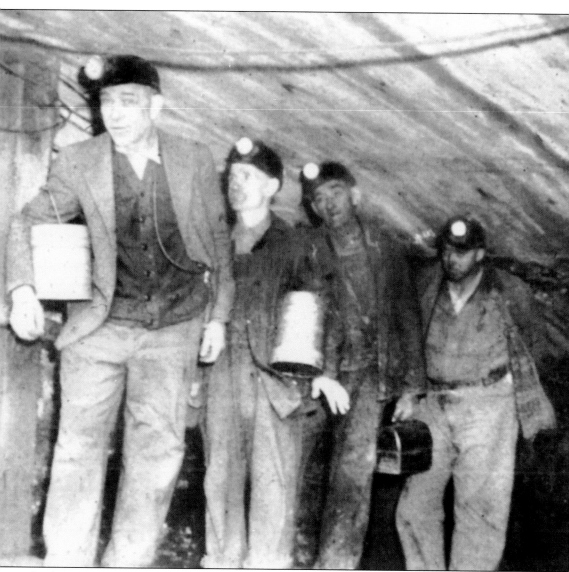

Coal mining was and is a very dangerous occupation. Many men died in the dark cavernous passages of the Van Lear mines. The most horrific single mine mishap occurred on Wednesday, July 17, 1935, in Mine No. 155. A section foreman and eight laborers were going to pull the track from a section where the floor was bowing. The floor was bowing due to a buildup of pressure caused by methane gas. The gas exploded and instantly killed all nine men: Jim Vaughn, Charley Kretzer, Bill Kretzer, Frank Tuzy, Roy Murray, Sherley Hereford, Honus Gool, Durward Litz, and Virgil Clay. Exactly what ignited the gas was never determined. It could have been an arc from a motor, a carelessly lit cigarette, or some other source of heat. The news of the explosion and the recovery efforts captivated the attention of the whole country. Mining continued at Mine No. 155 for several years after this tragedy. This photograph, from around 1940, shows a crew of men coming out of the mine after having worked their shift. Those pictured are, from left to right, John Sotnikoff, Charlie Bell, Miltie Castle, and Marion Ward. (Courtesy of the VLHS.)

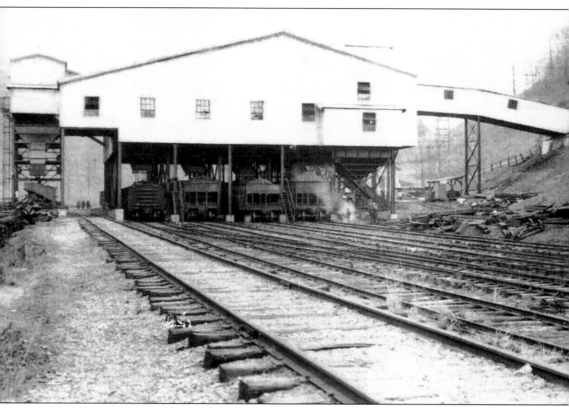

This photograph is of the steel tipple erected to replace the wooden tipple at Mine No. 155. During the final years of Consol's operating the mine, all production of Mines No. 155 and 154 were processed at this tipple. (Courtesy of the VLHS.)

These logos were used by Consol to promote and identify its genuine Miller's Creek coal. Exclusive franchises were issued by the company in many remote markets. The second depiction is that of a Miller's Creek scatter tag. These cardboard tags were scattered onto the rail cars of coal to identify its origin. The Miller's Creek coal was sold under the brand name of Grenadier coal. In earlier times, grenadiers were brave grenade-tossing soldiers. The origin of the word is French, literally meaning "grenademan." Early grenadiers were identified by insignia on the front of their high mitre hats. The insignia pictured in Consol's Grenadier logo includes a cross and a running horse. Some British grenadiers had the running horse of the house of Hanover included in their insignia. There appears to be some sort of running animal on the Consol Grenadier's mitre hat. (Both courtesy of the VLHS.)

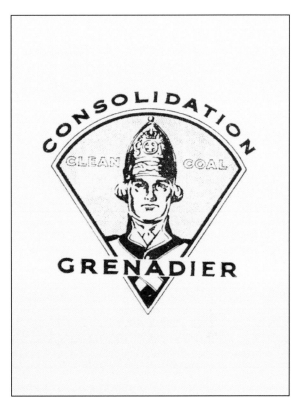

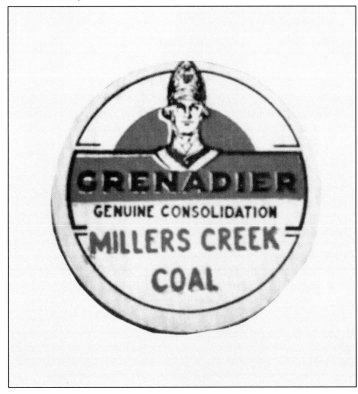

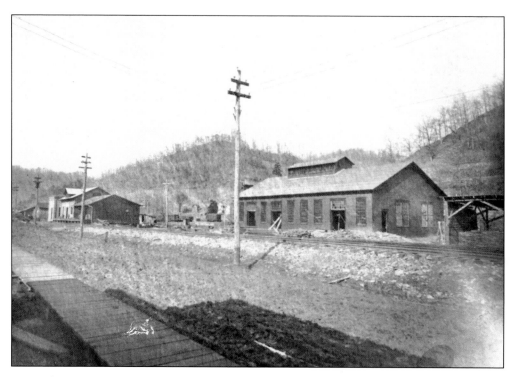

In the first photograph are a substation, a supply house, and the central machine shop. The central shop is located in the right central section of this shot. It was at the central shop that huge jobs too large in task or scope for the individual blacksmith shops were performed. The facilities in this photograph were located on the opposite side of Miller's Creek from the Mine No. 151 opening. In the photograph below is a group of workers at the central shop. These machinists and laborers were the unsung heroes of Van Lear. The miners have often been honored in the media, but these men who kept the mines running have too often been forgotten. (Both courtesy of the VLHS.)

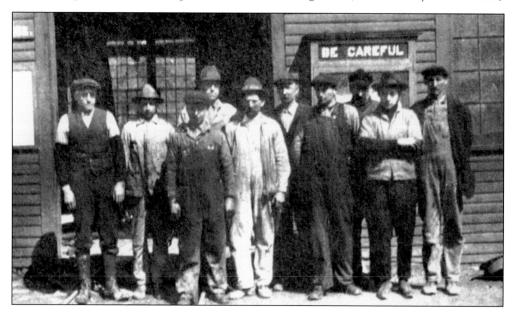

These two photographs show scenes from the central shop. In the scene above is a shop worker using an electric arc welder. In the early years of the 20th century, arc welding was a cutting-edge technology. Metal parts could simply be repaired rather than having to be replaced or worked by traditional blacksmithing techniques. The photograph below shows two air compressors that have been fabricated in the central shop. Air compressors allowed the use of impact wrenches and other tools that permitted workers to perform their duties in a more efficient manner. The items made and repaired at the central shop made it possible for Consol's Miller's Creek Division to be highly productive. (Both courtesy of the VLHS.)

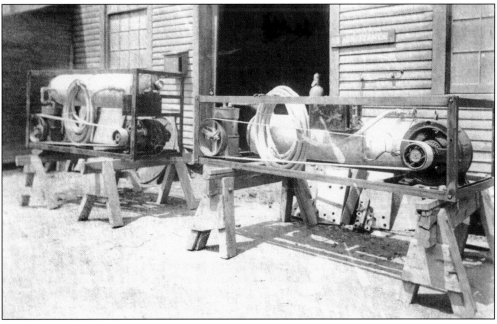

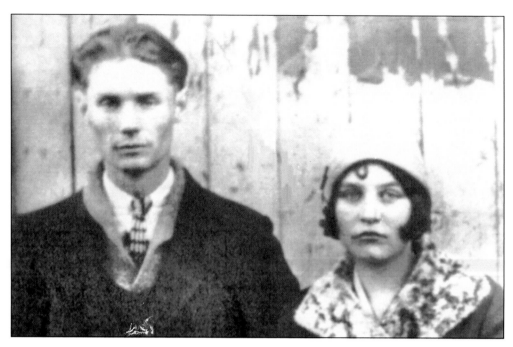

No one has brought more attention to the working-class people that lived in and around Van Lear than Loretta Webb Lynn. Pictured in the photograph above are a very young Melvin "Ted" and Clara Ramey Webb. Ted and Clara had eight children, four of whom had major recording contracts. These music stars are Loretta Lynn, Crystal Gayle, Peggy Sue Wright, and the late Jay Lee Webb. Thousands of fans make the journey to Butcher Hollow each year to visit the family's former home. The home is operated by another sibling, Herman Webb. By keeping the house in good repair, Herman has done more single-handedly for Eastern Kentucky tourism than anyone else. In the photograph below are recording stars Sonny and Peggy Sue Wright riding a Van Lear Volunteer Fire Department truck the 2006 Van Lear Parade. (Both courtesy of Peggy Sue Wright.)

Six

THE MILLER'S CREEK RAILROAD

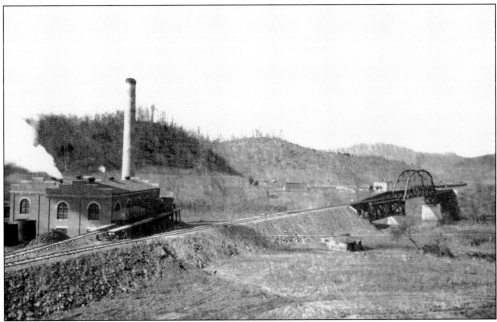

In order to market the Miller's Creek coal, a railroad was a must. Van Lear Black's Fidelity and Deposit Company loaned Consol the funds to build and equip the Miller's Creek Railroad (MCRR). The short line would run from Mine No. 155 to the Van Lear Junction (West Van Lear) and bridge the river at the central power plant. The total cost of the road and its equipment was $184,764.27. (Courtesy of the VLHS.)

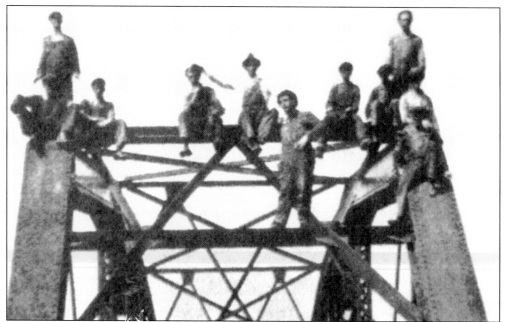

The photograph above shows a crew of the MCRR in 1910. They are perched high in a death-defying pose atop the newly constructed railroad bridge over the Levisa Fork. The photograph below is of locomotive engineer William "Will" T. Bradley. He began working for Consol in 1883 at the Allegheny Mine at Frostburg, Maryland. Will began his railroad career with the Cumberland and Pennsylvania in August 1897. On September 15, 1909, he began working as the engineer for the MCRR. When construction of the river bridge was completed, he took the first train across it on January 24, 1910. The first railcar of coal was loaded on January 29, and on January 31, it and five additional cars were hauled out of Miller's Creek. Much of this information originally came from William Bradley's daughter, Bertha Bradley McKay. (Both courtesy of the VLHS.)

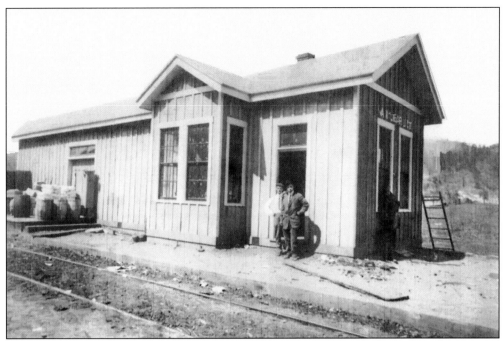

The construction of the MCRR included the building of a small station, which is shown in the first photograph. It was located at the junction of the MCRR and the main line at what is now West Van Lear. One of the station agents who worked at this depot was Grady Benjamin Medearis. The MCRR ran from this station to Mine No. 155. The MCRR was a standard-gauge, single-track road that had a total of 4.33 miles of main line and 0.8 mile of side track. The photograph below is a rare inside look at the station. The identity of the man on the left is unknown, but the fellow on the right is Grady B. Medearis. (Both courtesy of Gloria Martin.)

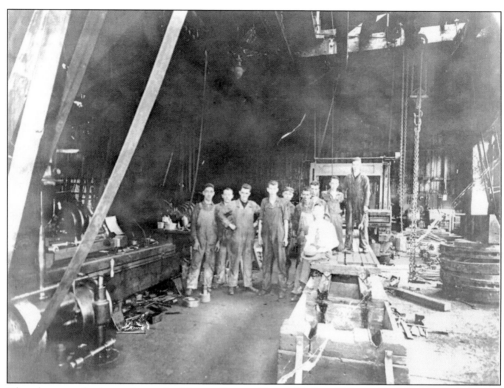

The photograph above shows the Mount Savage Train Works of Mount Savage, Maryland. The first iron rail for railroad use was manufactured at this shop. These shops were maintained by the Cumberland and Pennsylvania Railroad (C&PRR), which was owned by Consol. In addition to servicing the C&PRR, the shops also manufactured locomotives. Some of the rolling stock of the MCRR was actually manufactured at Mount Savage. The first steam locomotive of the MCRR was brought from Parkersburg, West Virginia, by William T. Bradley. It is unknown whether this first train was a Mount Savage product. The locomotive in the photograph below is No. 1, but it is not known if this is the original engine that Will Bradley had delivered. (Above, courtesy of the Patrick H. Stakem collection, used with permission; below, courtesy of the VLHS.)

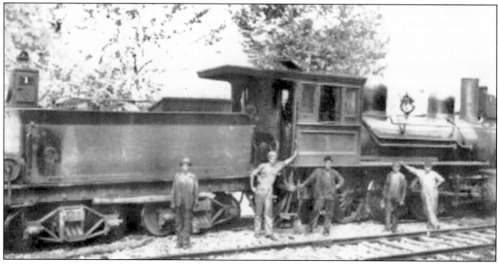

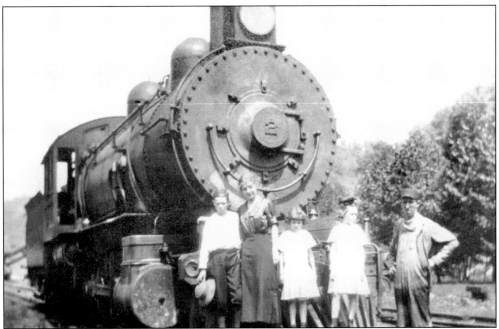

In the photograph above is Miller's Creek Engine No. 2. Standing in front of the locomotive from left to right are Eddie Bradley, Bess Bradley, Bertha Bradley, Ann ?, and William T. Bradley. In the photograph below is Miller's Creek Engine No. 3. Locomotive No. 3 was originally C&PRR Engine No. 18 but was sold to the MCRR and the identification number changed. It was built at the Mount Savage train shops in 1888 with a wheel configuration of 2-8-0. It is not known whether the engines of the MCRR were consecutively numbered or not. The total number of engines the system owned and operated throughout the years is also not known at this time. (Above, courtesy of Bertha Bradley McKay; below, courtesy of the VLHS.)

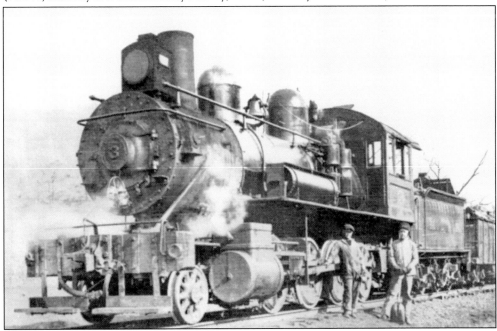

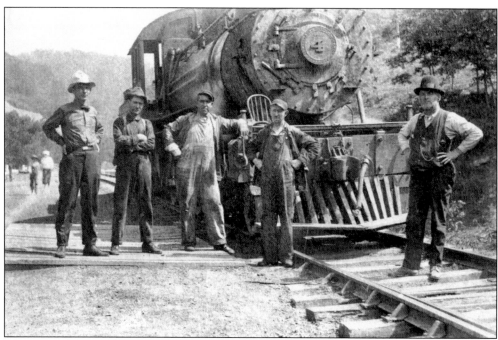

These two photographs are of Miller's Creek Railroad Engine No. 4. This engine too, was built for the C&PRR. It was assembled in 1889 and originally had the identification number of 20. The second photograph shows a snow-covered Engine No. 4 and locomotive engineer William T. Bradley. There was at least one other C&PRR engine that was sold to the MCRR. C&PRR's Engine No. 59 became Miller's Creek's Engine No. 19. This engine also had the configuration of 2-8-0. Records show that the Mount Savage shops worked on engines Nos. 1 and 2, but it is unknown at this time if these are the same as the Miller's Creek engines that bore these very same numbers. (Both courtesy of the VLHS.)

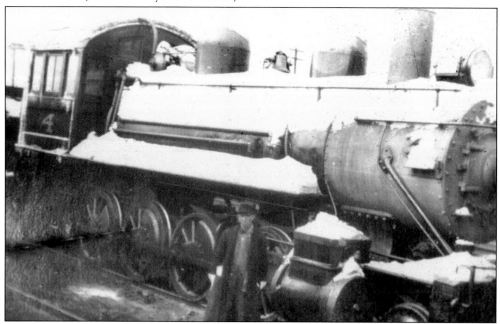

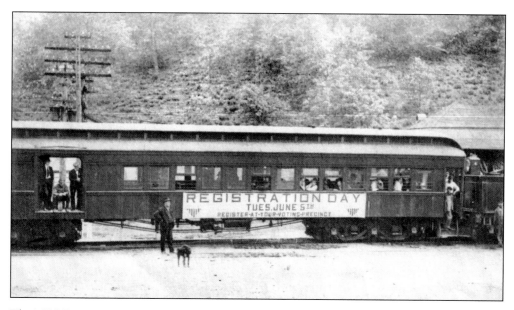

The MCRR was not just a coal hauling system but was a multipurpose utility railroad. The MCRR ran a regular passenger service, delivered freight cars to the company stores, and brought supplies to the company shops. Other specialty railcars included a firefighting car (shown below), railed steam shovels, and a railed logging car. In the photograph above is a train crew standing beside a passenger train. Notice the passenger cars are identified as being part of the Chesapeake and Ohio Railroad (C&O). The MCRR was originally owned by Consol, and then it was sold to the Baltimore & Ohio Railroad. Consol repurchased it in July 1923 and later sold it to the C&O. (Both courtesy of the VLHS.)

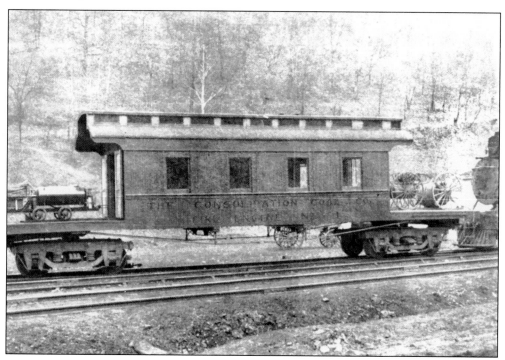

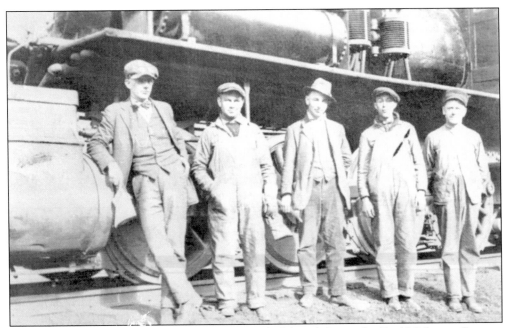

The photograph above is of a train crew composed of, from left to right, Fred Hickman, Emmett Poole, George Rupert, Canie Conley, and Adam Johnson. The photograph below shows an accident on the MCRR and reminds one that even short-line railroads can have mishaps. The worst single accident on the MCRR occurred on Sunday, January 2, 1911. The train had been pulling loaded coal cars to the junction when a number of the cars broke from the moving train. The crew did not realize what had happened and delivered what they thought to be their complete string of coal cars. It was dark on the return trip, and no light was used. William Akers, John Worley, L. G. Pindon, F. E. Fugate, Lemuel Mills, and L. A. Smeltzer were all killed. Akers and Worley were employees, and the others were simply riding along. (Above, courtesy of Charles Spears; below, courtesy of the VLHS.)

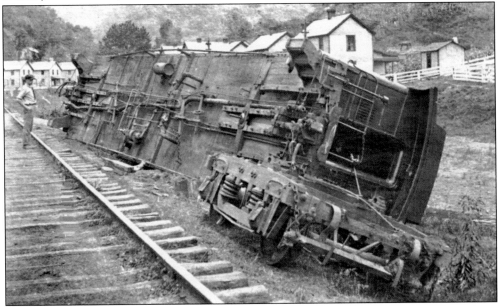

Seven

MEDICAL CARE

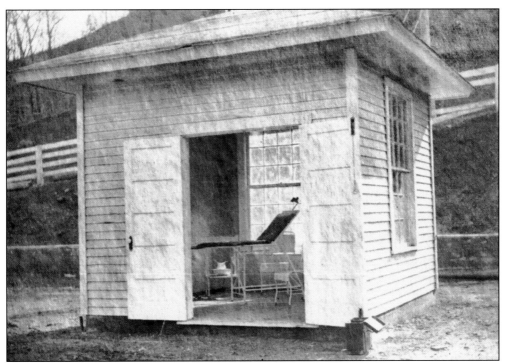

This photograph shows the Mine No. 155 emergency hospital. Medical services were offered by physicians and dentists hired by the company. Meager fees were regularly withheld from workers' wages to help offset the cost of these medical providers. In addition to doctors, first aid teams were maintained at each mine so that, in case of an accident, trained individuals were on the scene. (Courtesy of the VLHS.)

Dr. John Lyon was the second doctor hired by Consol at Van Lear; the first doctor was Dr. James C. Sparks. An announcement that ran in the *Paintsville Herald* of October 29, 1914, told of Dr. Sparks moving from Paintsville to Van Lear. Dr. Lyon moved his family from Ashland in the spring of 1916. The Lyon family moved into the former residence of Herbert H. Queen, who had moved to Louisa. According to his son, the late Silva Lyon, "Many a person has told me about his coming and staying all night with their sick loved ones." Dr. Lyon returned to Ashland in 1928. Tragically he died of a cerebral hemorrhage on December 29, 1929. He died just one month short of his 46th birthday. (Courtesy of the VLHS.)

In the photograph at right is Dr. Maurice M. Price. He descended from two of the oldest families in Johnson County, the Price and Preston families. Price was a contemporary of Dr. Lyon. In the photograph below is an early doctor's office. This office appears to be similar to, or possibly one of, the mine emergency hospitals. Some of the other early physicians who practiced in Van Lear were Dr. Isaac Lipskey and Dr. Eugene Davis. Doctors Lipskey and Davis were active members of the Johnson County Medical Society. Dr. Lipskey held the office of vice president of the organization. (Both courtesy of the VLHS.)

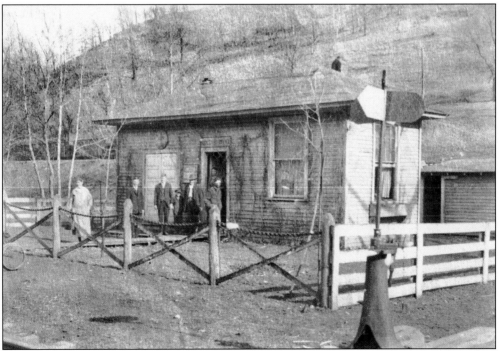

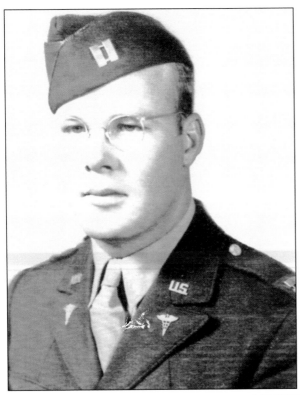

Dr. Olma Demera "O. D." Sparks Jr. is shown in the photograph at left. He was the son of Olma D. and Hattie Castle Sparks. Dr. Sparks was a graduate of Van Lear High School, the University of Kentucky, and the University of Louisville Medical School (1942). Upon graduating, he substituted in the medical office of Dr. John W. Turner for a month. His private medical career was postponed because he was drafted into military service. Later his life was cut short as he developed throat cancer. The photograph below is of Dr. John W. Turner. Dr. Turner was the last doctor maintained by Consol. His office was in the company's office building. Many are familiar with Dr. Turner because of his mention in both the book and movie *Coal Miner's Daughter*, which relate the story of Loretta Webb Lynn. (Left, courtesy of Howard Sparks; below, courtesy of the VLHS.)

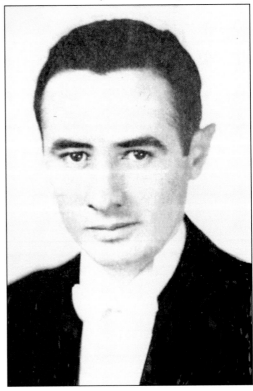

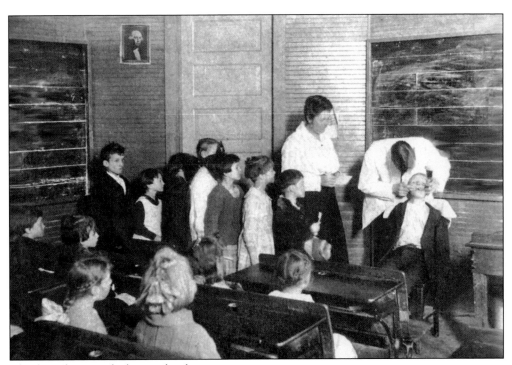

The first photograph shows school children receiving a dental check-up. The dentist is unidentified, but it is very probable that it is Dr. Lynn Bartlett Wolfe. Dr. Wolfe was married to Eva Lillian Kennedy of West Milford, West Virginia. The Wolfes lived for a while in the clubhouse. Later a newspaper reported that Eva Wolfe had been to Van Lear to visit her husband and had returned to West Virginia. It is believed that Dr. Wolfe later practiced in Charleston, West Virginia. His dental chair is on display at the Coal Miners' Museum in Van Lear. The photograph at right is of another dentist, Dr. Yamshon. According to a mention in an issue of Consol's *Mutual Monthly Magazine*, this Jewish dentist was one of the best-natured men in town. (Both courtesy of the VLHS.)

In addition to highly skilled medical doctors and dentists, the health and welfare of the people was served by other individuals and programs. In the photograph above is Miss Boyd, a visiting nurse. These nurses made daily jaunts to the miners' homes; not only did they give basic medical advice, but they also conducted classes in sewing and other domestic sciences. In the photograph below, a group of men display the awards they have won at a safety meet. These contests were generally held on the lawn of the Rec in central Van Lear, but the winners could potentially advance to higher levels of competition, culminating in a national championship. This award-winning team was made up of, from left to right, Tob Fairchild, Dewey May, Gene Auxier, Bernard Greer, Howard Painter, and Joe Sarshfield. Sarsfield served as the team captain. (Both courtesy of the VLHS.)

Eight

THE SCHOOLS

Miller's Creek had been served by two one-room county schools, but as Consol developed the town, an independent school system was established to serve the children of Van Lear. The first superintendent of this system was Forest Pendleton Bell of Hartford, Kentucky. This photograph shows Bell with a group of teachers. The teacher standing at the extreme left of the group is Margaret Motter. She was formerly a member of the facility of Hood College before coming to Van Lear. She was the sister-in-law of Consol's general manager for Van Lear, E. R. "Jack" Price. Margaret Motter never married and spent her entire life in public service. Motter died at her home in Frederick, Maryland, on December 13, 1984, at the age of 91. (Courtesy of the VLHS.)

The second superintendent of the Van Lear schools was Carlos V. Snapp. Snapp was born in Carlisle, Kentucky, on December 7, 1888. He began teaching at age 18 but took a break to serve in the army during World War I. After leaving the service, he accepted the position as the superintendent of Van Lear City Schools. While at Van Lear, he married a young teacher, Gussie Webb. After leaving Van Lear, he took the helm of the Jenkins Independent Schools for over 30 years. Then he served as the superintendent of Pikeville City Schools for two years, and he served as the director of pupil personnel for Pike County Schools. After retiring, he was a member of the Jenkins Independent School Board until 1986. On Sunday, January 8, 1990, the 101-year-old educator passed away. (Courtesy of the VLHS.)

Jess Holland came to Van Lear to be a coach but eventually became head of the entire school system upon the departure of Snapp. The photograph below shows the men who would become the fourth and fifth superintendents, Verne P. Horne (left, and below left) and Hysell Burchett (below, right). Both men began their service with the Van Lear schools as classroom teachers. During the days of racial segregation, Horne would teach the black children after the regular school day had ended. Horne was a capable leader who, after leaving the superintendent's post at Van Lear, became the superintendent of Johnson County Schools. Burchett then became the fifth and final superintendent, as the system consolidated with Johnson County Schools. Burchett continued to faithfully serve the children of Johnson County in various capacities until his retirement. (Both courtesy of the VLHS.)

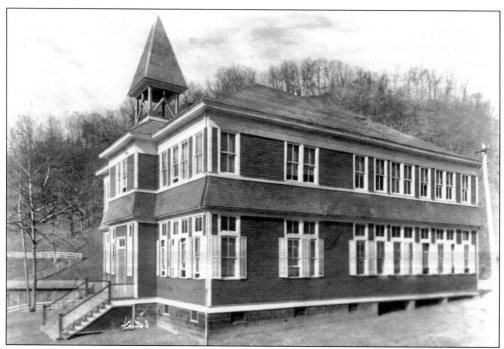

The building in the photograph above is the Van Lear Central School. Originally the Van Lear school system had three elementary schools with no high school. The Greentown School was a one-room school located in the western section to serve the children of lower Van Lear. Another one-room school stood at the mouth of Peavine Branch. This school served the students living in the vicinity of Mine No. 155. The centrally located school served all of the children living between the other two schools. The Upper Miller's Creek School was also open, but it was operated by Johnson County Schools. The central school, as pictured, had an annex built onto it to accommodate high school classes. The photograph below shows the Van Lear High School building. (Both courtesy of the VLHS.)

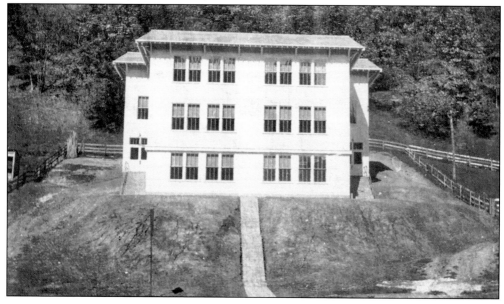

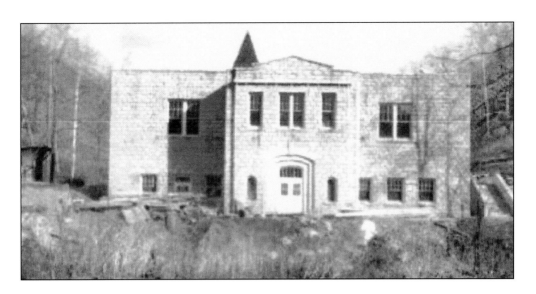

The Van Lear gymnasium is shown in the above picture. It was constructed of locally quarried stone by the WPA. Today it serves as a lodge hall for the Van Lear Masonic Lodge. In the photograph below is the school for African American children. In earlier times, classes for blacks were held after the regular school day was over for the white children. This was Van Lear's attempt at Jim Crow separate-but-equal laws. In addition to being used as a school, the facility served as a lodge hall and church for blacks. It is apparent that times have changed when one considers the grand marshal for the 20th Annual Van Lear Town Celebration was Lt. Col. Harry T. Stewart Jr., a Tuskegee Airman. Stewart had crashed a plane here in 1948 and was rescued by locals. (Both courtesy of the VLHS.)

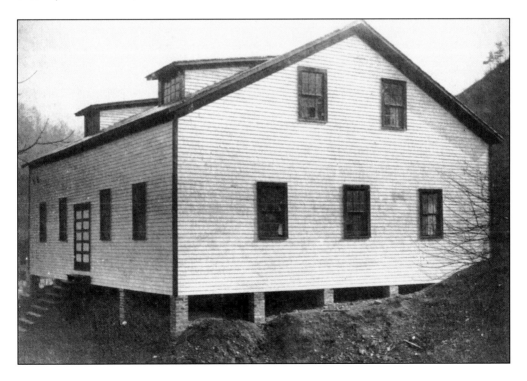

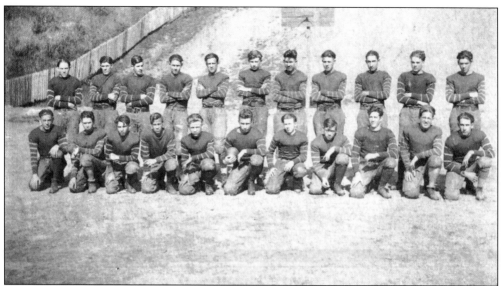

In the 1920s, football was a major sport for the fledgling school. From left to right are (first row) John Price, Sam Auxier, Paul "Nig" Wetzel, Hershell McAllister, Rupert Young, Eugene Auxier, Perry Snyder, unidentified, Dan Cyrus, Angeous Shearer, and Henry Conley; (second row) Elmer Price, Ochell Daniels, Art McCoart, Norman Snipes, Homer Shearer, Eldon Pickrell, Virgil Porter, Edmond King, Homer Cunningham, Virgil Phelps, and Warren W. Auxier. (Courtesy of the VLHS.)

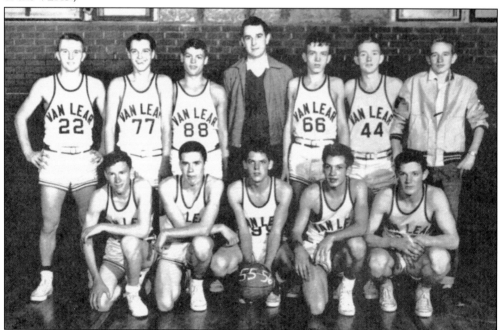

Later football would be dropped and baseball and basketball teams would proudly represent Van Lear High. In this photograph are, from left to right, the following: (first row) Delmadge Fannin, Robert Music, Gary Clifton, Ronnie Clifton, and Alex Sam Wells; (second row) Larry Joe Adams, Danny Hitchcock, Danny Eugene Blevins, Billy Lee Conley, James Fisher, Charles Webb, and manager Bill Adams. The school's mascot was the bankmule. (Courtesy of the VLHS.)

Nine

NOTABLES, THEN AND NOW

Van Lear resident William Riley Adkins is shown at 99 years of age. His parents were from Tazewell County, Virginia, but moved to Kentucky. William R. Adkins was born on January 1, 1822, in Kentucky. When he was young, his family lived in what is today West Van Lear. His father was a licensed distiller. In the days before the expansion of the railroad, they transported whiskey and brandy to Catlettsburg and Greenup by oxcart. It was a three-day trip one way. William was also a veteran of the Civil War. (Courtesy of the VLHS.)

Shown in this photograph are Walter S. "Scobe" and Amanda Short Akers. Scobe Akers was born at Miller's Creek in 1867. He was the son of Robert N. and Nancy Porter Akers. Amanda Short Akers was the daughter of Sales Short of Buffalo, Kentucky, now known as Meally. Scobe and Amanda had four children: Nancy, Elizabeth, Bill, and May. (Courtesy of the VLHS.)

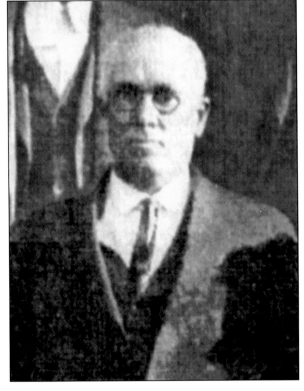

Pictured here is Richard Starr "Doc" Jordan. He taught at Van Lear during the tenure of Superintendent Bell. Richard Jordan was born in Irad, Kentucky, on July 10, 1871. After departing Van Lear, he returned to his native Lawrence County, where he continued teaching. He served as superintendent of Lawrence County Schools from 1920 to 1934. Doc Jordan died at age 69 at his home near Louisa, Kentucky. (Courtesy of the VLHS.)

Dr. James Edmund "Eddie" Congleton was born in 1901 in Slade, Kentucky, to George Washington and Annie Wells Congleton. Congleton began his teaching career at Van Lear in 1925 serving as a teacher and football coach. He became a noted neoclassic scholar and author. Dr. Congleton was twice a Fulbright lecturer. He taught for 22 years at the University of Florida and retired from Findley College in Ohio. (Courtesy of Caroll Congleton Parrish.)

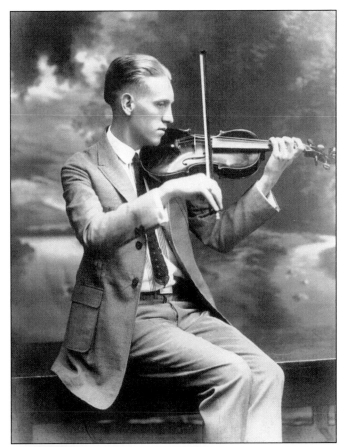

Left to right are Sam Watkins, chief of police George Spears, and Green Conley. These men were members of the Van Lear City Police. On July 16, 1925, officers Watkins and Conley attempted to arrest two men suspected of having alcohol. One of the suspects shot and instantly killed Sam Watkins in the process of resisting arrest. The last Van Lear policeman was Chief Darrell Preston, during the second incorporation. (Courtesy of the VLHS.)

Van Lear's highest ranking military officer was Vice Adm. Frank Hoblitzell Price Jr. Price was born and lived in Van Lear until he left for the U.S. Naval Academy in 1937. After he graduated from Annapolis, he served on destroyers. Price was on the USS *O'Brien* when it was sunk off Guadalcanal. He was also on the USS *Shubrick*, which was seriously bombed during the invasion of Sicily. He also saw action at the invasion at Normandy and at Southern France. Later Frank Price Jr. attended Ordnance Post Graduate School and then went on to the National War College in Washington, D.C. Other assignments saw him with the embassy in Madrid, Spain, in command of the USS *Beale*, and as commander of Destroyer Division 362. Price trained under Adm. Hyman G. Rickover and had command of the first nuclear cruiser, the USS *Long Beach*. He was promoted to rear admiral in 1968 and commanded Cruiser-Destroyer Flotilla 8, after which he returned to Washington, D.C. Price was promoted to vice admiral in 1972. His last duty was as deputy chief of naval operations for surface warfare. (Courtesy of the VLHS.)

This photograph is of Van Lear native Pfc. Onda Murphy, the son of Everett and Addie Powers Murphy. His story and that of another Johnson man are tragically bound together. Curtis Burchett was the son of Willie and Alta "Caudill" Burchett of Stambaugh, Kentucky. Murphy and Burchett left Paintsville during the same draft call and spent their entire time in the service together. Both soldiers were in the invasion of North Africa and Sicily together, and both were killed on D-Day, June 6, 1944. They were buried in the same cemetery in France until their bodies were exhumed and shipped back to Johnson County at the same time. Services for Onda Murphy were held in the Christian Church at Meally, and then he was laid to rest in his family cemetery on December 16, 1947. The next day, services were held for Curtis Burchett at the Beech Grove Baptist Church, followed by burial in his family cemetery. Private Burchett was the uncle of well-known science educator Mike Burchett of the East Kentucky Science Center. (Courtesy of the VLHS.)

In the years after the departure of the Consolidation Coal Company, many people have owned and operated stores. Some of the merchants were Abe Goble, George M. Wells, Richard "Icky" Wetzel, Oba and Clara Austin, Bill and Frankie Cantrell, Oval "Red" and Rhea Music, Danny E. and Phyllis Blevins, Herman and Patsy Webb, John C. Spriggs and Angie Spriggs Collins, Otto and Lola Collins, Jimmy and Patty Lee, and Kathy and Al Farley. In the photograph at left is Richard "Icky" Wetzel. Icky ran a restaurant and store called Kaye's Novelty Shop in the basement of the old Consol office building. His store was named for his niece, Kaye Stapleton. In the photograph below is the Oba and Clara Austin family. The little girl is Frankie Austin, who would one day marry Bill Cantrell. The little boy is Jack Austin. (Left, courtesy of the Wetzel family; below, courtesy of Frankie Austin Cantrell.)

Pictured are William Russell Rice (left) and coach Adolph Rupp. Russell Rice was born on November 7, 1924, the son of Russell Ganes and Alpha Bowe Rice. He was a three-letter man at Van Lear High. Rice began his writing career at Whitesburg, Kentucky, as the city editor for the *Mountain Eagle*. Later he worked at the University of Kentucky, retiring as the assistant athletics director. (Courtesy of William Russell Rice.)

Shown in this photograph are James E. and Wanda Lee Rice Vaughan. James's Van Lear nickname was "Tedo." He was born in Ashland, Kentucky, and reared in Van Lear. His father was one of the men who perished in the 1935 explosion at Mine No. 155. James has distinguished himself as an author and educator. Two of his publications have centered on Van Lear: *Blue Moon Over Kentucky* and *Bankmules*. (Courtesy of James and Wanda Lee Vaughan.)

Van Lear's future holds much promise, as the girls pictured were members of the 2006 International Future Problem-Solving Championship team from Porter Elementary. All but one of the team were from Van Lear. From left to right are Rachel Pescosolido of Prestonsburg and Kayla Fannin, Olivia Ellis, and Tracy Blevins, all of Van Lear. They defeated teams from 46 states and foreign countries. (Courtesy of Porter Elementary.)

Van Learian and Pratt-Whitney employee Jason M. Conley is a 1998 graduate of Paintsville High. He received his bachelor's degree in aerospace engineering from the University of Alabama. Jason works with the space shuttle program at Kennedy Space Center and is working on two additional advanced degrees. Jason is the second Van Learian to work at the cape. James Fisher also worked there until his retirement. (Courtesy of Jason M. Conley.)

BIBLIOGRAPHY

Beachley, Charles E. *History of the Consolidation Coal Company 1864–1934*. New York: Consolidation Coal Company, 1934.

Connelley, William E. *Eastern Kentucky Papers: The Founding of Harmon's Station*. New York: The Torch Press, 1910.

Hall, C. Mitchell. *Jenny Wiley Country*, vol. 3. Kingsport, TN: Kingsport Press, 1979.

Lynn, Loretta, and Vecsey, George. *Coal Miner's Daughter*. Warner Books, 1976.

Turner, Carolyn Clay, and Traum, Carolyn Hay. *John C. C. Mayo, Cumberland Capitalist*. Pikeville, KY: Pikeville College Press, 1983.

Van Lear Historical Society, Inc. *The Bankmule*, vols. 1–23. Van Lear, 1984–2007.

Vaughan, James E. *Bankmules: The Story of Van Lear, a Kentucky Coal Town*. Ashland, KY: Jesse Stuart Foundation, 2003.

———. *Blue Moon Over Kentucky: A Biography of Kentucky's Troubled Highlands*. Delaplaine, AR: Delapress, Inc., 1985.

Discover Thousands of Local History Books Featuring Millions of Vintage Images

Arcadia Publishing, the leading local history publisher in the United States, is committed to making history accessible and meaningful through publishing books that celebrate and preserve the heritage of America's people and places.

Find more books like this at
www.arcadiapublishing.com

Search for your hometown history, your old stomping grounds, and even your favorite sports team.

Consistent with our mission to preserve history on a local level, this book was printed in South Carolina on American-made paper and manufactured entirely in the United States. Products carrying the accredited Forest Stewardship Council (FSC) label are printed on 100 percent FSC-certified paper.

MADE IN THE USA